T0354043

"Iwasaki Tsuneo's stunningly beautiful paintings of life and universe, rendered with lines of masterful miniature calligraphy of the Heart Sutra, reveal an infinite potential of dynamic interaction between scientific findings and the timeless wisdom of Buddhist teaching."

—KAZUAKI TANAHASHI, author of *The Heart Sutra: A Comprehensive Guide to the Classic of Mahayana Buddhism*

"Iwasaki's luminous calligraphies, set in striking paintings both traditional and contemporary, are a remarkable gift to meditators, Buddhists, artists, and scientists of the contemporary age. Paula Arai is uniquely qualified to bring these paintings to a larger audience, given her mastery of Japanese language, culture, and religion; the trust bestowed on her by Iwasaki's family; and her own Buddhist practice. Given the universal appeal of the Heart Sutra and its calligraphy, this book is destined to become a timeless treasure returned to again and again for its inspiration and sheer beauty."

—JUDITH SIMMER-BROWN, author of *Dakini's Warm Breath: The Feminine Principle in Tibetan Buddhism*

"Japanese calligrapher and painter Iwasaki Tsuneo reveals to us a wondrous universe suffused with the light of the Buddha's enlightenment experience. He does so by embedding the characters of the Heart Sutra, a famous Mahayana scriptural text, in depictions of the macrocosmic Big Bang scene, of the microcosmic double helix in the DNA molecule structure, as well as of ordinary landscapes and natural scenery. Paula Arai's magnificent book lays out the visual imagery and provides a delightfully written and highly insightful guide to Iwasaki's art. This is a breathtaking glimpse of our intimately interconnected universe."

—RUBEN L. F. HABITO, Guiding Teacher, Maria Kannon Zen Center and author of *Healing Breath: Zen for Christians and Buddhists in a Wounded World*

"We are so fortunate to have the chance to see the truly awe-inspiring paintings of Iwasaki Tsuneo expressing the wisdom and compassion of the Heart Sutra. Each painting meets the viewer with images that unfold the teachings in a deeply moving and healing way. Dr. Paula Arai demonstrates incredible devotion to the artist and to seeing that his vision and work be shared as a beneficial force in the world."

—LINDA RUTH CUTTS, Senior Dharma Teacher, San Francisco Zen Center

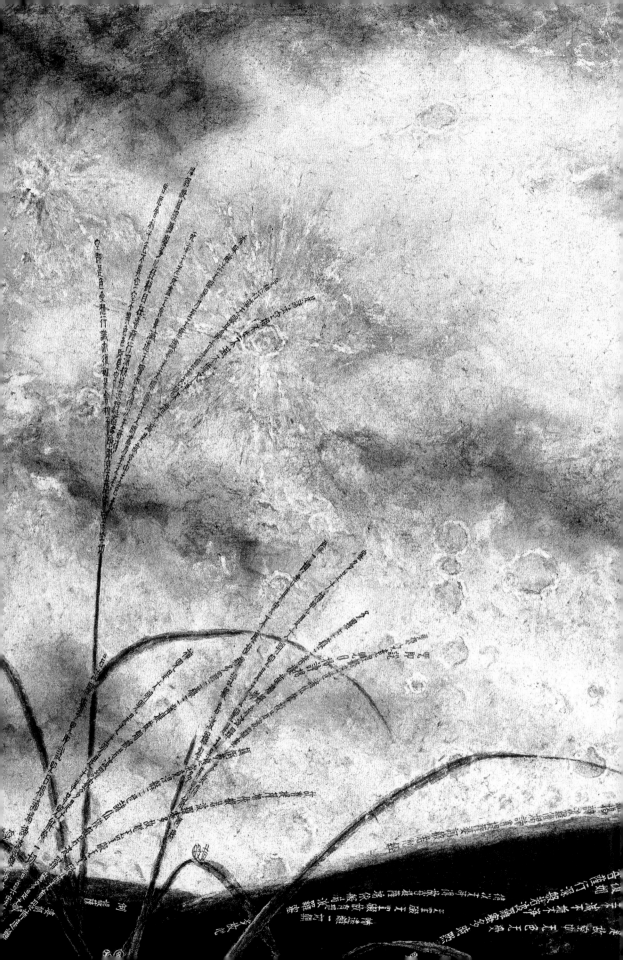

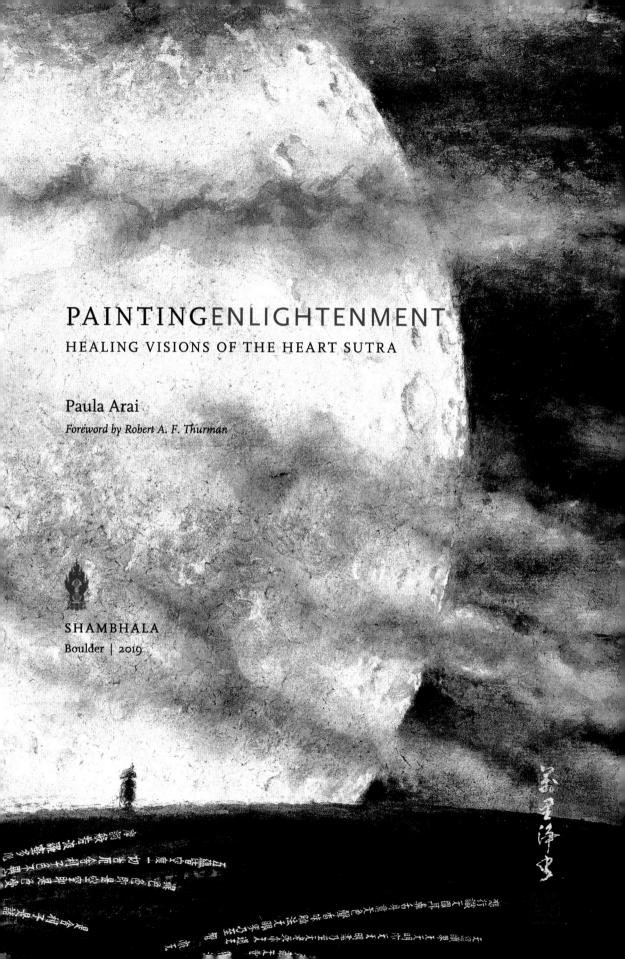

PAINTINGENLIGHTENMENT

HEALING VISIONS OF THE HEART SUTRA

Paula Arai

Foreword by Robert A. F. Thurman

SHAMBHALA

Boulder | 2019

Shambhala Publications, Inc.
2129 13th Street
Boulder, Colorado 80302
www.shambhala.com

©2019 by Paula Kane Robinson Arai

All rights reserved. No part of this book may be reproduced in
any form or by any means, electronic or mechanical, including
photocopying, recording, or by any information storage and retrieval
system, without permission in writing from the publisher.

9 8 7 6 5 4 3 2

Printed in the United States of America

⊗This edition is printed on acid-free paper that meets the
American National Standards Institute z39.48 Standard.
♻ Shambhala Publications makes every effort to print on recycled
paper. For more information please visit www.shambhala.com.

Shambhala Publications is distributed worldwide by
Penguin Random House, Inc., and its subsidiaries.

Designed by Kate E. White

Library of Congress Cataloging-in-Publication Data
Description: First Edition. | Boulder: Shambhala, 2019.
Identifiers: LCCN 2018050409 | ISBN 9781611807561 (pbk.: alk. paper)
Subjects: LCSH: Iwasaki, Tsuneo, 1917–2002—Criticism and
interpretation. | Tripiṭaka. Sūtrapiṭaka. Prajñāpāramitā. Hṛdaya—
Illustrations. | Tripiṭaka—Copying. | Calligraphy, Japanese. | Buddhist
calligraphy—Japan.
Classification: LCC NK3637.193 A87 2019 | DDC 759.952—dc23
LC record available at https://lccn.loc.gov/2018050409

For

Iwasaki Sensei,
Kenji,
Kai,
and all who seek healing

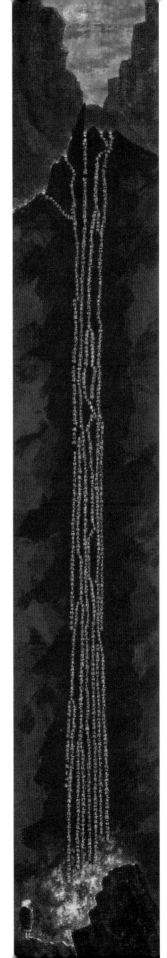

CONTENTS

LIST OF ILLUSTRATIONS

FOREWORD BY ROBERT A. F. THURMAN

The magnificent art presented in *Painting Enlightenment* draws you into its world of perfect balance, wise knowing, and compassionate feeling, resonating with the beauty of nature in all its dimensions. Generous, selfless, patient, creative, and transformative—we open this sumptuous book and are at once so blest.

These works are Iwasaki Tsuneo's miraculous gift to us all, born of his scientific intelligence, his patient suffering, and his determined love of life—his openness to horror and tragedy as well as beauty and astonishment. He met Avalokiteshvara, the Buddha God of Loving Care, known as Kannon in Japan, in the *Perfect Wisdom Heart Sutra*. They enjoy nirvanic communion in the emptiness that is not dark nothingness, the emptiness that is the womb of the universal compassion that nurtures all beings with the vital force of freedom.

Iwasaki lived in the redeeming home he found in the world of the *Heart Sutra*, which is enfolded within the Buddha's samadhi field called "illumination of the profound." Iwasaki witnesses the eternal moment when Bodhisattva Kannon experiences the perfect freedom of his own body and mind, together with all beings. Both Bodhisattva and artist honor this sutra as the Bhagavatī, the Mother of All Buddhas, the Perfect Wisdom Goddess who shares the science of freedom with every being. As Kannon teaches her liberating code in the sutra, Iwasaki offers its open field to all by painting that sensitive freedom of enlightenment into every macro and micro thing. He infuses each with the sutra's Chinese characters, streaming with the Japanese sacred sounds. He masterfully demonstrates how blades of grass, living beings, black holes, big bang cosmic explosions, and everything in between hum the same teaching of freedom, love, and beauty, born of the fusion energy of science and spirituality.

Blessed Dr. Paula Arai has also found a spiritual home in this gracious buddhaverse, moved to her heart's core by Iwasaki's intense devotion and enlightened artistry. She is deeply inspired to share the

shelter with us lucky ones who open up this book. Her ingenious curation of the paintings expresses the noble eightfold path of lucid realism in a totally new and beautiful way. The realistic worldview is *Interbeing*, life-purpose is *Flowing* within it, speech is *Nurturing* awareness, evolutionary action is *Forgiving* self and others, livelihood is *Offering* one's gifts, creativity is *Awakening* to beautify the buddhaverse, mindful awareness is *Playing* with all that is, and realistic samadhic entrancement is *Flourishing* in sharing the bliss of utter freedom!

I bow to Buddha; to Kannon; to their Mother, Bhagavatī Perfect Wisdom; to Iwasaki Tsuneo; and to Dr. Paula Arai, and I welcome and commend to you all this masterpiece of a book, an amazing doorway to the wondrous glory of the deathless life of artful compassion.

Robert A. F. Thurman
Jey Tsong Khapa Professor of Buddhist Studies, Columbia University
President, Tibet House U.S.
Woodstock, New York
February 5, 2019, New Year's Day, Earth Boar Year

ACKNOWLEDGMENTS

The vibrant stream flowing from Iwasaki's compassionate hands in small-town Handa, Japan, has reached across the seas due to the vital energy thousands have poured into it. Many have strengthened my quest to share Iwasaki's art through nourishing my work as an educator, writer, public speaker, workshop leader, and sometimes curator. Though I am unable to name each person on the page, please know your support is inscribed in my heart.

To the people who made exhibitions of Iwasaki's art possible at Louisiana State University Museum of Art, Crow Collection of Asian Art, Austin College, The Zentner Gallery, DePauw University Peeler Art Center, Institute of Buddhist Studies, Jodo Shinshu Center, and the Mind & Life Institute's International Symposium on Contemplative Studies, my gratitude is effervescent.

For the students in dozens of classes and the thousands of people who have witnessed the power of these paintings through slide presentations, exhibitions, workshops, and contemplative events, my gratitude is expansive. Like the stuffed animal in *The Velveteen Rabbit* that comes to life by being loved, each of you has brought this art out of obscurity and into the living stream of healing beauty. This is especially true of two anonymous attendees at an exhibition. One mother shared how Iwasaki's art helped her heal while facing the suicide of her son. Another mother came to heal so she could live long enough to raise her young children, despite her terminal cancer diagnosis.

To the scientists who offered their expertise, including Dr. Sascha duLac (neuroscientist), Dr. Stephen Scaringe (biochemist), Dr. Ravi Rau (quantum physicist), Dr. Dominique Homberger (evolutionary biologist), Dr. Geoff Clayton (astrophysicist), Dr. Kelly Reed (microbiologist), and Jemma Wolcott-Green (mathematical cosmologist), my gratitude is indissoluble. To artists who helped me see the art through their arts, Tenzin Norbu (Thangka Master

at Norbulingka Institute in Dharamsala), Michelle Bach-Coulibaly (dancer and choreographer at Brown University), Dr. Liza Dalby (scroll mounter), and Kaz Tanahashi (Zen calligrapher), my gratitude is sublime.

For use of photographed images of Iwasaki's art, my gratitude to Suzuki Hisashi-san of Nichibō Press is sincere. For digital photography, my gratitude to Kevin Duffy is earnest. For crucial financial support from the Urmila Gopal Singhal Fund at LSU, my gratitude is fervent. For bringing this book to fruition, especially the Shambhala Publications editors Dave O'Neal, Matt Zepelin, and Audra Figgins, my gratitude is voluminous. For the fundamental support of the Iwasaki family, my gratitude is unceasing.

To those who have provided visionary guidance, avid affirmation, jewels of scintillating wisdom, and strong ramparts to sustain me, especially Dr. Bob Thurman, Dr. Miranda Shaw, Dr. Hal Roth, Dr. Ivette Vargas-O'Bryan, Dr. Lisa Prajna Hallstrom, Dr. Tara Doyle, Dr. Ruben Habito, Dr. Paul Ramsour, Dr. Stephen Addiss, Dr. Steve Jenkins, Dr. Beth Conklin, Adrienne Caddel-Hopkins, and Michelle Thomson, my gratitude is transcendent.

For Kito Sensei, Yuriko Sugiura, my partner Kai, and my son Kenji, my gratitude for your oceanic support, profound patience, and loving care from near and far is wholehearted and boundless.

To the incalculable multitudes of causes and conditions that have contributed to this volume, I am honored and humbled to be part of ushering this stream along even as I am buoyed by the support of our interdependent web.

With palms together and head bowed,
Paula
San Francisco, July 2018

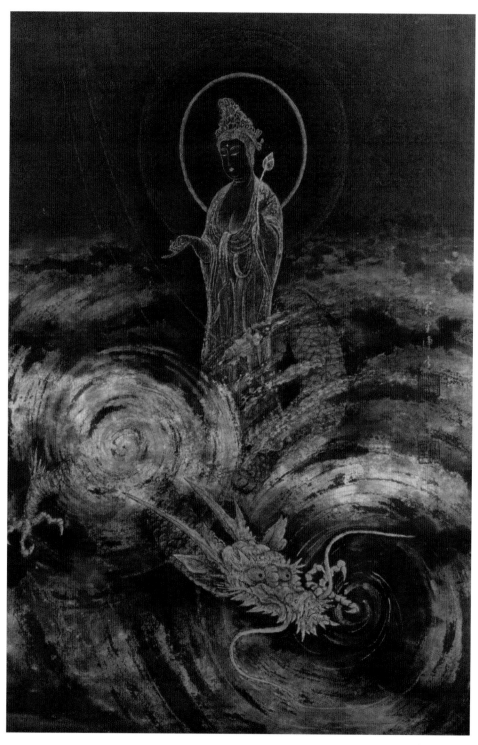

"Dragon-Riding Kannon" is one among numerous forms of the Bodhisattva of Compassion, including Avalokiteshvara, Chenrezig, and Guan Yin. *Kiryū Kannon* detail.

HEART OF THE PERFECTION OF WISDOM SUTRA

The Sutra on the Heart of Realizing Wisdom Beyond Wisdom
by Kazuaki Tanahashi and Joan Halifax[1]

Avalokiteshvara, who helps all to awaken,
moves in the deep course of
realizing wisdom beyond wisdom,
sees that all five streams of
body, heart, and mind are without boundary,
and frees all from anguish.
O Shariputra [who listens to the teachings of the Buddha],
form is not separate from boundlessness [emptiness];
boundlessness is not separate from form.
Form is boundlessness; boundlessness is form.
Feelings, perceptions, inclinations, and discernment are also like this.
O Shariputra,
boundlessness is the nature of all things.
It neither arises nor perishes,
neither stains nor purifies,
neither increases nor decreases.
Boundlessness is not limited by form,
nor by feelings, perceptions, inclinations, or discernment.
It is free of the eyes, ears, nose, tongue, body, and mind;
free of sight, sound, smell, taste, touch, and any object of mind;
free of sensory realms, including the realm of the mind.
It is free of ignorance and the end of ignorance.
Boundlessness is free of old age and death,
and free of the end of old age and death.
It is free of suffering, arising, cessation, and path,
and free of wisdom and attainment.

Being free of attainment,
those who help all to awaken
abide in the realization of wisdom beyond wisdom
and live with an unhindered mind.
Without hindrance, the mind has no fear.
Free from confusion, those who lead all to liberation
embody profound serenity.
All those in the past, present, and future
who realize wisdom beyond wisdom,
manifest unsurpassable and thorough awakening.

Know that realizing wisdom beyond wisdom
is no other than this wondrous mantra,
luminous, unequalled, and supreme.
It relieves all suffering.
It is genuine, not illusory.

So set forth this mantra of realizing wisdom beyond wisdom.
Set forth this mantra that says:

GATÉ, GATÉ, PARAGATÉ, PARASAMGATÉ, BODHI! SVAHA!

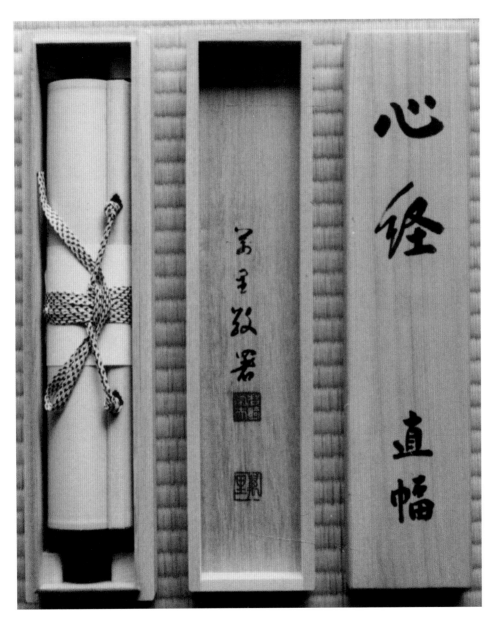

Iwasaki *Heart Sutra*
scroll painting in
signed wooden box.

罣礙无罣礙故无有恐怖遠離一切顛倒夢

想究竟涅槃三世諸佛依般若波羅蜜多故

得阿耨多羅三藐三菩提故知般若波羅蜜

多是大神咒是大明咒是无上咒是无等等

咒能除一切苦真實不虛故說般若波羅蜜

多咒即說咒曰

揭諦揭諦　波羅揭諦　波羅僧揭諦　菩提薩婆呵

般若心経

岩崎萬里淨書

摩訶般若波羅蜜多心経

觀自在菩薩行深般若波羅蜜多時照見五

蘊皆空度一切苦厄舍利子色不異空空不

異色色即是空空即是色受想行識亦復如

是舍利子是諸法空相不生不滅不垢不净

不增不減是故空中無色無受想行識無眼

耳鼻舌身意無色聲香味觸法無眼界乃至

無意識界無明亦無無明盡乃至無老死

亦無老死盡無苦集滅道無智亦無得以無

PAINTINGENLIGHTENMENT

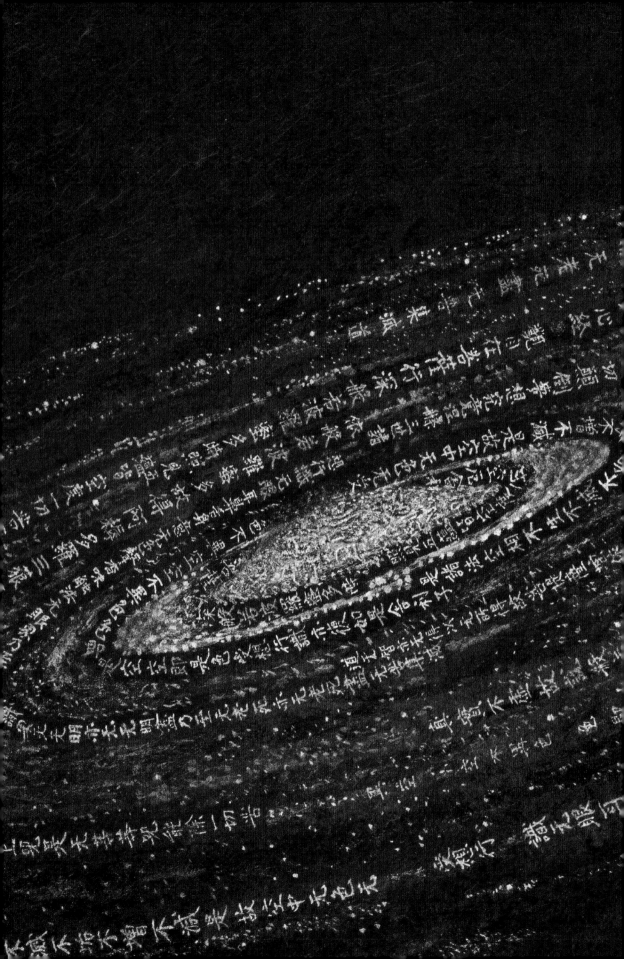

IWASAKI: SCIENTIST & HEALING VISIONARY

The truth expressed in the [Heart] sutra is everywhere to be seen; it is in our mind, the beginning and end of which are unknown.

—KŪKAI (774–835)

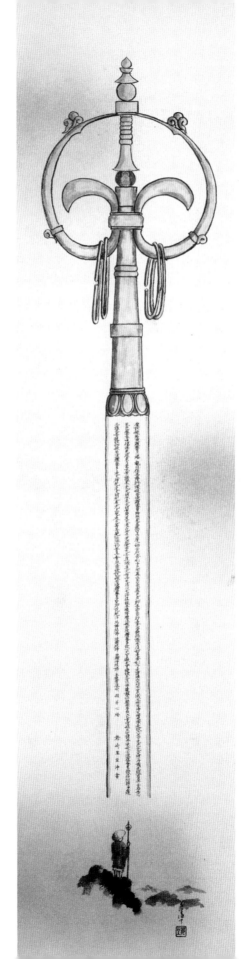

TRANSFORMATIVE JOURNEYS

It was raining that early spring evening in Nagoya when the phone rang. Nagai-san's elegant voice greeted me with a buoyant tone as she skipped the usual polite ritual exchanges and went straight to the heart of her concern. She was one of the elder women sharing her experiences with me as part of my research on Buddhist healing practices. "Paula-san, I finally understand. Emptiness is not cold. It is what embraces us with compassion, enabling us to live, move, breathe, even die." In earlier conversations, she had expressed frustration that despite having diligently studied the Buddhist philosophical concept of emptiness, comprehension had eluded her for years as she sought relief from the suffering of numerous losses. She had lost her two elder brothers to the deprivations of World War II, her parents to age hastened along by outliving two of their five children, her mentally ill elder sister to suicide after her parents were no longer there to care for her, and her younger sister to homicide at the hands of her newlywed husband. "Today I went to an exhibit of *Heart Sutra* paintings," she told me. "Upon seeing them I *felt* how warm and wonderful emptiness is. Tomorrow is the last day of the exhibit. You *must* go see for yourself."[2]

Venturing out the following morning, two-year-old son in one hand and umbrella in the other, I trudged my way to the museum through a downpour. I wondered how paintings could possibly help anyone see, much less feel, emptiness. On arriving, I immediately understood. Standing amid scenes of dewdrops, ducklings, and dragons, a luminous stream of nourishing, embracing wisdom flowed from the paintings into my heart. My Harvard doctoral training in Buddhist philosophical thought and textual analysis did not yield the insights these paintings delivered directly in potent visual form. I aspired to meet the artist and puzzled how I could navigate the labyrinth of introductions that would be required to make his

OPPOSITE:
Shakujō Staff
(80 x 22 cm)

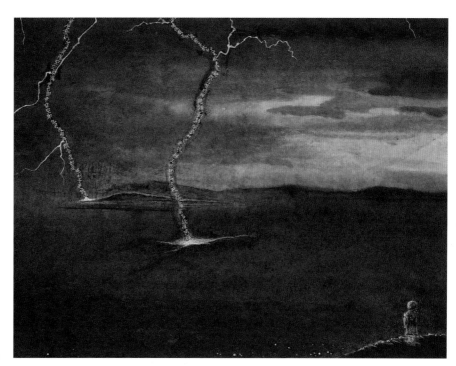

Lightning detail.

acquaintance. Fortuitously, the artist, Iwasaki Tsuneo[3] (岩崎常夫) (1917–2002), was present to close this five-day exhibit. In our initial conversation, I had no idea the lithe and humble figure I met that day was among the veterans that the Japanese Imperial Army had abandoned to a living hell on a Southeast Asian island for a year beyond the end of World War II. In the years ahead, though, I would learn a great deal about this man. Two weeks later I took the first of what would be countless train rides to his modest home in a small town an hour beyond the metropolis of Nagoya. On that visit I was surprised to discover that the creator of the masterful paintings who had spoken to me so eloquently had not started painting until the sixth decade of his life, after retiring from his career as a biologist. Over the next three years, Iwasaki revealed ever deeper layers of his motivations and creative process, including the original question that inspired him to take up a paintbrush: "How do I pass on what I've learned about life, death, and healing?" He passed away without knowing that His Holiness the Dalai Lama would one day bless his art for its power to illuminate resonances in Buddhist and scientific views of reality.

When I first turned the corner at the Chinese restaurant tucked among the homes along the narrow streets of Iwasaki's neighborhood, I did not know that I was setting forth on a journey of spiritual and artistic discovery that would last for decades. I was simply flushed with excitement to talk with a man who had found a way to express

enlightenment in his art. Though awakening is commonly claimed to be inexpressible, it has not prevented Buddhists across diverse cultures and multiple time periods from generating words, images, and practices to foster its realization. One of the most cherished efforts is a short scripture known as the *Heart Sutra*, or more formally, *Heart of the Perfection of Wisdom Sutra*. I later learned Iwasaki thought of it in terms of a colloquial and more informative title: *Scripture on the Heart of Liberating Wisdom and Compassion*.[4]

The historical origins of the *Heart Sutra* trace from 150 C.E. India to seventh-century C.E. China, depending on whose story you follow.[5] Prominent in East Asian liturgical and devotional settings over the centuries and prized for its brevity (276 characters in the Japanese version), it distills the core Mahayana principles of wisdom and compassion. In other words, it is not easy to understand. Perhaps this is why it has garnered more commentaries than any other sutra.[6] It has inspired creative ways to access its emancipating power, including being carried in a pouch close to the heart, chanted under the breath in moments of fear, bellowed in times demanding great power, intricately brushed on grains of rice, copied on reams of paper upon the death of a loved one, ingested one syllable at a time for wisdom insights, embedded in buildings, and clutched during childbirth. Some have shaped the Chinese characters of the sutra to form pagodas and Buddha images as creative expressions of deep reverence. In these manifold ways, this text has been woven into people's lives for well over a millennium, generating a rich and sacred material culture. Few people who engage in these practices, however, would claim to understand the philosophical meaning of the text. Iwasaki's novel inspiration was to shape the characters of the *Heart Sutra* to form lightning bolts, atoms, black holes, and DNA to illuminate the meaning of the sutra.

My mind racing with questions and my heart burgeoning with respectful awe, I stepped through the gate of Iwasaki's home and into the front garden, a tiny oasis of green that provided an immediate sense of quiet calm. Formal bows quickly softened into joyous smiles as we exchanged our delight in having a chance to talk. I was honored to be

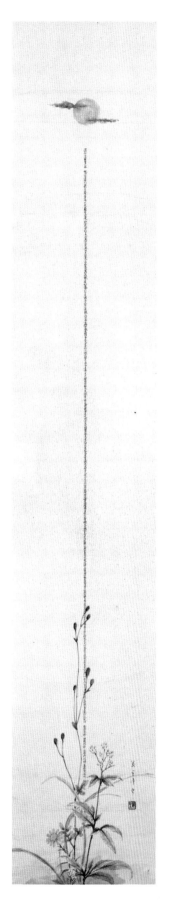

Autumn Flowers (105 x 17 cm)

Iwasaki at home after finishing a silver
and gold version of *Radiating Pearl*.

welcomed into the home of a profoundly wise artistic genius. He was struck that a Western-trained Buddhist scholar was interested in his paintings. He already knew my basic background—I was on sabbatical in Japan to do Fulbright-funded research on healing rituals. He also knew my impression of his art—because I had written him a letter. Doing so was an effort to repair the breech of Japanese custom I committed on that day we met at the museum. In the august, high-ceilinged gallery where his paintings hung in testimony to his wisdom and artistry, I had to introduce myself empty-handed, because instead of business cards, I had tissues in my pocket.

Sitting in the formal *tatami* room of his home, I gazed out the wall of windows overlooking the front garden. I felt awkward having my back to the traditional *tokonoma* alcove where objects of beauty are hallowed. That day it was graced by his painting of Bodhidharma and an elegant arrangement of flowers. I had been placed in the seat of honor. Being across the table from Iwasaki, I felt a momentous gravity. It was the kind of moment when Zen masters invoke the phrase *Ichi go. Ichi e.*—One time. One meeting. To consecrate the occasion, I asked if I could make an offering at the home altar that was enshrined to the right of the alcove. Thereafter, all my visits at the Iwasaki home began with the traditional ritual of lighting a candle and incense, then ringing the bell and bowing to an image of Amida Buddha in the altar. Since Iwasaki's passing, I always tear up when I bow, but on that day my heart filled with gratitude for having a chance to personally thank him for his insightful art. Over tea I requested permission to make slides of the paintings in his exhibition catalog. I told him how I was excited to share them with my students back in the United States, for I could imagine how in viewing his paintings they would better understand the *Heart Sutra* and the meaning of emptiness. Though humble, his smile betrayed his delight in the thought that he could in some way help teach students in America.

Over several cups of tea, I learned he was born on July 9, 1917, into a Kyoto family that highly valued education. Along with his six sisters, he, too, became a teacher. He was also deeply committed to research. Upon the passing of his father, however, as eldest son his filial piety drove him to leave his research at the Agriculture Department of Tokyo University and move back home to care for his mother.[7] Years earlier, the family had moved to the quiet town of Handa on the Chita Peninsula, quite removed from the ancient capital city. With no university nearby, Iwasaki secured a position teaching biology at the

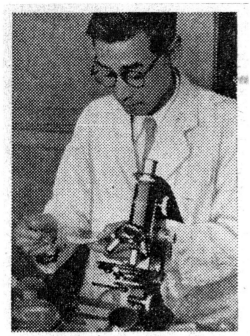

研究を続ける岩崎教諭

Iwasaki featured in the
newspaper on June 17,
1954, upon winning
a national grant for
research on silkworms.

Handa Girls' High School and the Boys'
Junior High School from 1941 to 1960,
continuing to teach at various schools
until 1996.[8] Although rare for a secondary
schoolteacher, he was highly disciplined
and maintained an active research agenda
throughout his career. Driven even then to
share his knowledge—despite the inherent
challenges of limited time, resources,
and support—he circulated his primary
research on silkworms through national
conference presentations and published
articles (one of which was translated into
French). His efforts won him a prestigious
national grant from the Japanese Ministry
of Education. Iwasaki's creative, practical,
and resilient temperament shone through
the way he quietly persevered in balancing a
life in which he could pursue his wide-ranging passions.

With concrete plans for me to visit again the following week, I
prepared to leave, warmed by a deep sense of connection. I was not

Iwasaki at a
temple lecturing
on *Mandala of
Evolution* on
January 25, 2002.

prepared, though, for what happened next. With the twinkle in his eye I had already come to adore, he beamed one of his incandescent smiles. Iwasaki removed his *Bodhidharma* (see page 104) painting on display in the formal alcove. He handed me the painting saying, "Please, it's for you." I was stunned into a long, silent bow of gratitude, forehead down to floor, tears welling up. My mind has returned to that occasion many times over the years, mystified why he chose that painting. One day a flash of revelation struck. It was the koan: "Why did Bodhidharma come from the West?" Bodhidharma is famed for transmitting Buddhist teachings into new lands. The gift of the painting carried his prayer that the message embodied in his art would reach people beyond the islands of Japan.

Though unaware of this spacious vision, after that first meeting I solidified my resolve to share his art far and wide. I joined him in attending lectures on Zen by famed author and Zen priest Matsubara Taidō (1907–2009), whose book *Introduction to the Heart Sutra* was long-running on the best-seller list.[9] For years Matsubara traveled from his temple, Ryūgen-ji, in Tokyo to lecture at the Chūnichi Cultural Center in central Nagoya. After lectures, while sipping tea, Iwasaki and I often dwelled on the intricacies of Buddhist concepts and reflected how fathoming them helped us see our beautiful but beleaguered world more deeply.

Over the course of our conversations, Iwasaki expressed his purposive response to the ecological and human crises of modernity. Witnessing the horrors of war in the nuclear age and triumphs of technology in the twentieth century, he felt driven to ameliorate the fragmented attention, environmental destruction, and personal and communal violence that threaten our survival. He found a way to express how scientific knowledge and Buddhist wisdom can enrich and expand one another, with science revealing the necessity and external means of intervention and Buddhism offering an alternative to the greed, hatred, and fear that spawn planetary misery.

It became clear to me that Iwasaki was a visionary thinker who cared deeply about the fate of the world. As a seer at the vanguard of civilization, Iwasaki merges the three streams of Buddhist spirituality, science, and art, generating a powerful current that carries the imagination into new and vibrant

Silkworm (83 x 17 cm)

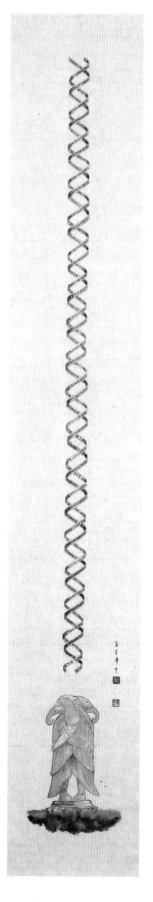

waters. His innovative artistry harmonizes resonances he discovered between scientific and Buddhist views of reality; he shaped the Chinese characters of the *Heart Sutra* into artistic imagery drawn from ephemeral beauties of nature, Buddhist cultural life, and microscopic and telescopic wonders. His choice of the *Heart Sutra* as the structuring element of his oeuvre indicates the philosophical underpinnings of his art.[10] Cognizant of our increasingly visual-media saturated world, his aim is to teach transformative wisdom to a broad cross-cultural audience, unimpeded by linguistic barriers.

An explicit characteristic of Iwasaki's art is that it accentuates the role the senses play in perceiving different dimensions of reality. Imagery and science are fundamentally reliant on sensory experience, but Buddhist teachings caution that our senses, if untrained in wisdom, can misinform us, leading to delusions that result in suffering. The untrained senses enable one to see what is conventionally real, but to see what is ultimately real requires a profound transformation of perception. Employing sacred words to form a vast range of images, Iwasaki's paintings guide the viewer to see wisdom encoded in the objects he portrays and, by extension, in all things.

The insatiability of Iwasaki's curiosity became clear as I learned more about his life. Never without a notebook, he was constantly learning and taking notes. His self-characterization with regard to Buddhism, however, was that he learned it by osmosis while growing up. Even though he was raised in a Buddhist cultural environment, it is notable that he consciously aspired to follow the Buddhist path from an early age. His deep-seated sincerity is evident, for instance, in a haiku poem he composed to the Buddha of Infinite Light at age seventeen.

南無阿弥陀　　Oh, Amida
せめて瞬時の　May even for a moment
まことかな　　True-heartedness be

In tune with the teaching that phenomenal reality—the reality of everyday appearances—is ultimate reality, he thought parents were the foundation of all sutras. For guidance in understanding parents as sutras, he turned to the *Sutra on the Profundity of Filial Love* (*Fuboonjūkyō*, 父母恩重経).[11] Integral to

Baby Bestowing Buddha (104 x 17 cm)

the Chinese transformation of the Buddhist teachings as they emerged from India, it is a Confucian-influenced sutra likely dating to the eighth century C.E.[12] It extols the boundless acts of compassion with which a parent cares for a child. Though the debt children accumulate is inexhaustible, the sutra petitions practical expressions of gratitude, such as readily coming to the aid of a parent in need. It also enjoins spiritual expressions, such as making offerings at an altar. Before his mother passed, Iwasaki only occasionally made offerings and chanted at the family altar, for she was the one who sustained the rituals at home. After her passing, moved with filial love, Iwasaki made offerings and chanted at the family altar at the beginning and end of each day.

As his awareness unfurled, his focus intensified. Iwasaki disclosed to me that he took the following verse from the *Dhammapada* as his "principle in life."[13]

Contemplation is the path of no death.
Negligence is the path of death.
The vigilant do not die,
Whereas the negligent are the living dead.[14]

The luminous threads of Buddhist teachings Iwasaki wove into his deep and personal exploration were enlivened with the healing wisdom of natural beauty that flourishes on Japanese soil. In contrast to other Buddhist cultures that have taken beautiful forms as traps of attachment that cause suffering, Japanese Buddhist culture highlights the beauty of forms as a path out of suffering. Kūkai (774–835 C.E.), the founder of an esoteric sect, Shingon, advances the Buddhist basis for this view in his teachings on the "Dharma-Body Preaching the Dharma" (*Hōsshinseppō*, 法身説法). He equates ultimate truth with phenomenal reality. In poetic terms, each dewdrop on a blade of grass teaches impermanence. Each time you hear a bird sing, you hear instructions on nondual wisdom. Spring rain turning into summer blossoms is a master class on the interdependent nature of reality. The fragrance of cherry blossoms wafting through the air is a sermon on the beauty of emptiness. The warmth of sunrays on a crisp winter day is a private

Buddha's Hair (83 x 26 cm)

lesson on the myriad of compassionate activities that support life. Nature is an expert teacher because natural forms live the teachings. So when Iwasaki looked through his microscope, he saw intricate details of the Buddhist teachings, planting seeds in his mind that would germinate in his evocative art.[15]

Iwasaki's compassion for all beings was forged in the crucible of war. Like many veterans, he preferred not to dwell on details of his wartime experience, but it was clear to me that the war revealed the depth of his commitment to life. He was twenty-four years old on April 10, 1942, when he began serving the Japanese Imperial Army. One among ninety thousand Japanese troops, he was deployed under Army General Hitoshi Imamura at the deep-sea harbor of Rabaul, New Guinea.[16] After the war, these troops were held in internment camps by the Allied forces of Australia, who did not provide much food. Many of the troops were farmers, so they became self-sufficient, preventing most from dying of starvation. Iwasaki also mentioned how they ate snakes and insects. Speculative debates about why Japan lost the war raged through the camps. Many thought the Japanese government had perpetrated a deficiency in science and technology training due to its insular educational aims.[17] In a stunning demonstration of resiliency, while held captive by their victors, General Imamura commanded the men to develop their skills in science and technology to be prepared to help restore war-ravaged Japan when they were finally repatriated.[18] As a commissioned officer, Iwasaki was responsible for teaching and developing curricula.[19] Being a biologist trained at one of Japan's premier universities, he conducted research practical for their survival by focusing on hawk moths (*Agrius convolvuli*, エビガラスズメ), which were a pest to their staple food, sweet potatoes. On May 26, 1946, nearly a year after the war ended, an almost twenty-nine-year-old Iwasaki finally returned to Nagoya.

SEEKING THE WISDOM OF THE *HEART SUTRA*

In the decades after his return to Japan, as he pursued a career as a teacher and biologist, Iwasaki looked for ways to transform his suffering on the front lines of war into compassion for all beings. He looked to different Buddhist teachings and practices for help in this regard, and nothing was more potent for him than his encounter with the *Heart Sutra*. His innovative and philosophically profound

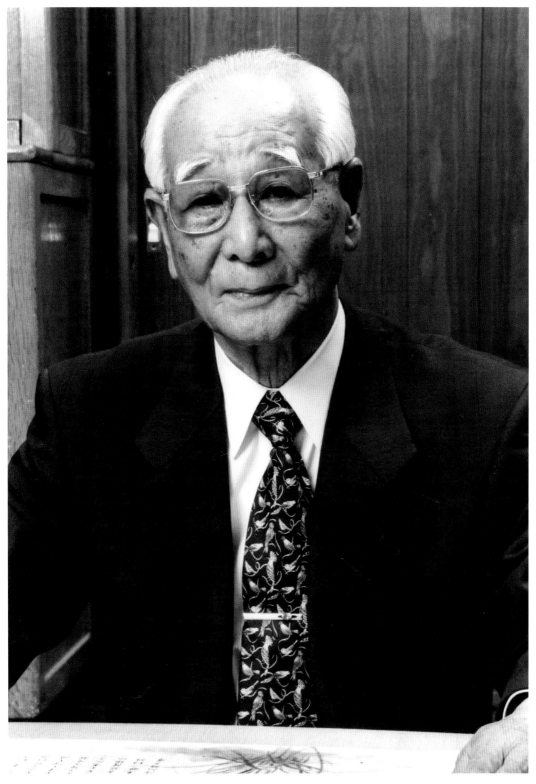

Iwasaki Tsuneo, 岩崎常夫
(1917–2002)

paintings show us what he learned: to view reality in a way that facilitates crossing over from suffering to not suffering. As a scientist, he honed his skills of observation of reality, an ability that helped him bring sustained and focused attention to the teachings found in the *Heart Sutra*. They helped him see the nature of wisdom as it pertains to perception and as it fosters compassionate action. Iwasaki engages the contemporary imagination by using the sacred words of this text to paint visual tropes of science, among them a hydrogen atom, the Andromeda galaxy, a strand of DNA, and a cosmic representation of $E = mc^2$. He weaves them together with Buddhist tropes of compassion such as Baby Buddha, Amida Buddha, Kannon, and Fudō Myō-ō. Through fusing these two modes of viewing reality, Iwasaki's art reveals the jewels buried deep in the interstices of the *Heart Sutra*.

The full title of the *Heart Sutra* in Sanskrit is *Mahāprajñā-pāramitāhrdayasūtra*. In Japanese it is *Makahannyaharamitashingyō* (摩訶般若波羅蜜多心経). Wisely, a Buddhist text about wisdom embeds the name of the Mother of All Buddhas, Prajñāparamitā, in its title. It also respectfully heralds her as wondrously great (Skt. *Mahā*; Jap. *Maka*) because her wisdom (Skt. *prajñā*; Jap. *hannya*) is about how to cross over (Skt. *pāramitā*; Jap. *haramita*) to the shore of enlightenment. This sutra promises to offer the heart (Skt. *hrdaya*; Jap. *shin*) of that venture. The *Heart Sutra* sets itself apart by cutting to the chase. It's as if the reader has just missed Shariputra, a disciple of the Buddha famous for asking questions, interrupting the bodhisattva of compassion—Kanzeon, the "one who hears the cries of the world" (commonly shortened to Kannon)—in the midst of deep meditation, to ask, "How do I cross to the other shore?" The reader arrives in time to hear Kannon's wise directions on how to navigate through the nature of reality.

The concise directions are clearly intended for someone familiar with the territory. In addition to pithy directions for how to cross over to a way of being free from suffering, Kannon also warns about obstacles you might encounter along the way. The qualities of this path are organismic, ever transforming, and liberating. Sense perceptions—sight, sound, smell, taste, touch, and, in the Buddhist tradition, consciousness—are a delicate matter, for they can easily misdirect one's attention. The forms you see and move in, the sounds you hear and scents you smell, enrich the way, so long as you do not stop and reify them. You must be careful with each step because at any moment you can head down the path of suffering. A tantalizing

object may capture your attention, and in pursuit of it, you veer off the path of liberation, all the while thinking you are about to attain something desirable. The warning signs that you have taken a turn away from the path of liberation include finding yourself reacting out of fear to something and clinging to an object for safety, only to find the experience like quicksand: the more you cling, the deeper you sink into fear. In other words, grabbing a hologram of a life ring will not keep you from drowning. So be careful to not perceive something to be something it is not. Be vigilant along the narrow and tricky pass of form and emptiness. The key is to not treat anything as separate from the interdependent flux of dynamic activity. If you experience everything, including yourself, as a living web of interdependent events, you will be released down the path of freedom from suffering.

Indeed, the most famous passage in the *Heart Sutra* is Kannon's caution to be aware that "form is emptiness; emptiness is form." The philosophical meaning of these sentences has been analyzed and debated across nearly two millennia. The key to understanding emptiness is to ask, "Empty of what?"[20] The answer is simple, independent existence. Other answers include inherent substance, separate entities, essence, solitary importance, and individual ontological status. Emptiness is full of connections, because emptiness is a description of the interrelated and ever-changing nature of everything. Emptiness does not mean nothing exists. Emptiness is the concept that there are no independent entities. Emptiness is a description of the quality of ultimate reality, but ultimate reality is not a place. It is a conceptual tool that points to the dynamic and interdependent activities that make up the universe. Form is a description of conventional reality, or what we experience through our six senses of sight, sound, smell, taste, touch, and consciousness. Conventional reality is also not a place. It is a term for the realm we perceive. What we perceive as objects and persons are ultimately boundless flows of energy in perpetual interaction and flux—our laughing and crying, working and playing, living and dying.

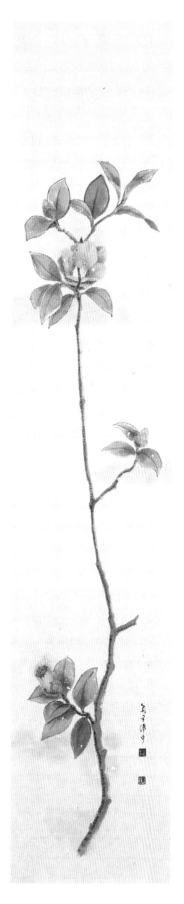

Camellia (105 x 19 cm)

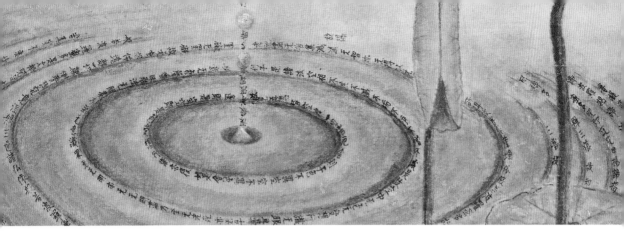

Lotus Dewdrop detail.

Nonetheless, our senses and mental processes shape reality into perceptible forms, such as raindrops and ants, me and you, good and bad.

Defining the terms *form* and *emptiness* in relationship to each other accentuates that everything is constantly transforming in a dynamic and interdependent flux. Emptiness and form are heuristic tools, just like all words. They are tools designed to help one navigate out of the realm of suffering and into the realm of nonsuffering. Form is a concept that reminds us it matters what we do, and emptiness is a concept that reminds us that everything is not as it appears. In short, the *Heart Sutra* encourages realization of the insubstantial and interdependent nature of all we perceive and enjoins compassionate activity to relieve suffering.

Iwasaki's paintings provide a visual expression of emptiness in a manner reminiscent of the legendary golden lion metaphor the seventh-century C.E. Buddhist master Fa-tsang devised to illustrate the relationship of form and emptiness. Fa-tsang likened emptiness to gold and form to a lion statue fashioned from gold. The lion statue seems solid and enduring, but, like all physical phenomena, it is impermanent. The malleability of gold—its absence of fixed form or state—makes possible the temporary form of the lion. Similarly, emptiness is the dynamic energetic matrix of reality that makes possible the arising of fleeting phenomenal forms. Forms depend on the potentiality of emptiness, while emptiness is only discoverable through the presence of forms. For example, if you wanted to look closely at a form, perhaps a hard rock, and you get close enough to see the electrons that make up the rock, you would see it as porous and pulsating with activity. Form is not a solid entity at all. Yet if you turn to see emptiness more closely and bump into a wall, you find out how hard emptiness can be! Just as we see the activity of gravity when we watch a flowerpot fall, we experience the activity of emptiness each time we hear a duck quack, smell a flower, or pet a cat.

Experiencing emptiness is experiencing interrelatedness. It is key to clearing away mental afflictions that obscure the nature of experience and tether one to suffering. Perception is the fulcrum upon which one travels along the path of suffering or liberation. Losing sight that emptiness is form and form is emptiness is easy to do. Therefore Iwasaki's paintings are valuable in that they are answers to these questions:

What does "form is emptiness; emptiness is form" look like, feel like, taste like, smell like, or sound like? By using a text on emptiness to create forms, Iwasaki shows us how to perceive ultimate and conventional reality simultaneously, in double exposure.[21]

In his paintings, conventional reality as experienced through the senses is superimposed on the ultimate reality of emptiness and interrelatedness. The intricate details of each form are made visible by invoking the plenitude of invisible interconnections that constitute the universe. Seeing in such double exposure is necessary to act with compassion. The reason for this is simple. You need to hear audible form—a cry—to know that someone needs help and where to go to help them. You need to see vision form—a hand—to know where to reach and feel the physical form to help someone who has fallen. Iwasaki's aim is for viewers to experience their interrelatedness with that which is ultimately important—everything—and thereby inspire caring. In painting an atom composed of Buddhas, he is asserting that, in its most fundamental being, everything is made of wisdom and compassion energy; all forms are impulses to support interrelated, ever-changing activity to diminish suffering. So you need to sense both the wisdom of emptiness and the forms of compassion.

Wisdom protects against mental afflictions that distort our perception of reality. Without the protection of wisdom, actions tend not to be in accord with reality. So the intended results of our actions fail to hit their marks, like trying to touch a spot on your shirt by viewing the reflection in a wavy funhouse mirror. Ultimate protection from such mishaps—and worse—comes from dissolving all mental afflictions and waking up to perfect wisdom. It's a tall order, as perfect wisdom is, by definition, a mark of enlightened beings. The Buddhist teachings, however, are optimistic. Not only do the teachings affirm that it is possible for all to cross to the other shore of enlightenment, but they also offer kind practices for support along the way. The *Heart Sutra*, in its wisdom and compassion, offers a mantra, a verbal troche, to soothe the mind until wisdom is perfectly clear.[22]

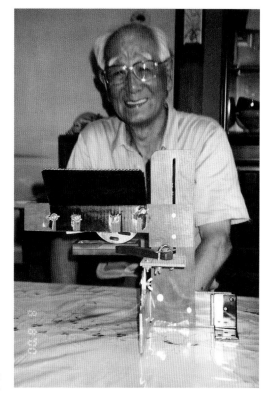

Iwasaki at home explaining his magnifying glass stand to author on August 8, 2000.

Taking their place in this grand tradition of aids for liberation, Iwasaki's paintings function like visual doses of medicine. Just as the power of the sutra is concentrated sonically in the mantra, the power of the sutra is concentrated visually in his paintings. He presents the wisdom teachings in the widely accessible form of art with the aim to help people heal from delusions and mental afflictions, to wake up. How did Iwasaki realize the insight to do this? He did not resist the circumstances of his life. He responded to the needful by distilling out mental afflictions that obscured his view of emptiness, whether fear in the midst of war or anger at behaviors that destroy our natural habitat. He transformed the energy released in those efforts into dedicating himself to deepening his understanding of our universe and finding ways to share what he learned along the way—not least through teaching young people. For him, painting was a devotional practice. He prayed, chanted, and offered incense to consecrate his paintings and instill them with healing energy. Iwasaki extends the ancient tradition of concealing a consecrated copy of the *Heart Sutra* in a healing amulet.[23] His paintings reveal the hidden power of the *Heart Sutra*, and he offers them as public talismans to all sentient beings.

LOTUS DEW INK AND PRAYERFUL BRUSHWORK

Iwasaki's work clearly has roots in the ancient Chinese calligraphy and ink painting tradition where brushwork reflects the qualities of the painter's spirit. Commencing formal calligraphy training at age fifty-five, he found a primary impetus for his creativity in the contemplative practice of scripture copying, *shakyō* (写経). Scripture copying is one of the ten practices noted in the *Mahāprajñāpāramitā Sūtra*.

> One who cultivates these ten practices
> Attains immeasurable blessings.
> [These ten practices are] superior and inexhaustible,
> Because they never cease benefiting beings. [24]

Scripture copying is a meditation centering on mindfully writing a scripture. In Japan it got its start as a state-sponsored effort to make the Buddhist scriptures available. To that end, Empress Kōmyō (701–760 c.e.) started the Office for Sutra Reproduction.[25] This systematic effort generated avidity among pious people with means to copy sutras, including lavishly embellishing the scrolls and making ornate cases

摩訶般若波羅蜜多心経
観自在菩薩行深般若波羅蜜多時照見五
蘊皆空度一切苦厄舎利子色不異空空不
異色色即是空空即是色受想行識亦復如
是舎利子是諸法空相不生不滅不垢不浄
不増不減是故空中無色無受想行識無眼
耳鼻舌身意無色聲香味觸法無眼界乃至
無意識界無無明亦無無明盡乃至無老死
亦無老死盡無苦集滅道無智亦無得以無
所得故菩提薩埵依般若波羅蜜多故心無
罣礙無罣礙故無有恐怖遠離一切顛倒夢
想究竟涅槃三世諸佛依般若波羅蜜多故
得阿耨多羅三藐三菩提故知般若波羅蜜
多是大神咒是大明咒是無上咒是無等等
咒能除一切苦真實不虚故説般若波羅蜜
多咒即説咒曰
掲諦掲諦 波羅掲諦 波羅僧掲諦 菩提薩婆訶
般若心経

Japanese *Heart Sutra* copying template 般若心経写経用紙 brushed by Iwasaki.

to protect the treasured texts.[26] In addition to being recognized as a meritorious practice, in the Heian period (794–1192) it became a devotional practice for healing or consoling the departed. Current research even suggests scripture copying positively stimulates brain activity.[27] The *Heart Sutra* is the most common sutra to copy.

The traditional practice of Buddha-image copying, *shabutsu* (写仏), also inspired Iwasaki. It is the practice of meditatively tracing an image of a Buddha or bodhisattva. The practice is founded upon Kūkai's teaching that you can experience Buddhahood with your own body-mind. He taught that "through painting the shape and form of a Buddha, your heart-mind becomes one with Buddha. You manifest Buddha heart-mind."[28] Derived directly and indirectly from this teaching, practices to cultivate the embodied mind thrive in Japanese culture.

The meditative dimensions of scripture copying and Buddha-image copying ignited Iwasaki's creative imagination and fueled his healing vision. A careful examination of the meanings that are combined in the two Chinese characters for meditation, *meisō* (瞑想), illustrates what Iwasaki was experiencing as he sat with a straight spine and relaxed limbs, quietly brushing each stroke. The first character, *mei* (瞑), is an aggregate of eye (目), light (日), and the number six (六). The second character, *sō* (想), is an aggregate of tree/ stability (木), eye (目), and heart-mind (心). Meditation, then, is to steadily illuminate your six senses to see through your heart-mind. For over two decades, Iwasaki practiced this for hours a day to beget his

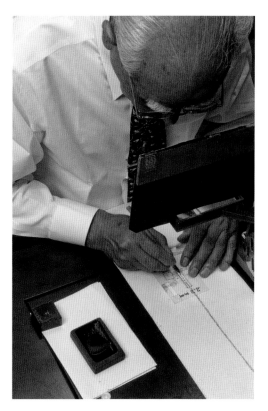

Iwasaki brushing the
Heart Sutra in *sumi* ink.

art. Supported by his wife, he maintained a disciplined routine to generate the conditions to support his meditative practice. His gratitude for her efforts imbues each stroke of ink.

Spending time with Iwasaki in his work space, I was stunned by the vastness of his mind and the strength of his imagination. That he sat on the floor and painted at a two-by-four-foot low table was unremarkable in Japan. After we started talking about the details of his process, it dawned on me that many of his paintings, such as the five feet, eleven inches square *Mandala of Evolution*, would not fit on the table. Iwasaki saw the strain in my face as I fixed my puzzled gaze on the table. He volunteered, "I roll the *washi* (traditional Japanese fibrous paper). It coils in my lap and then flows over the far edge of the table. I also put pieces of paper together when necessary." Humbly eliding his astonishing ability to visualize a highly refined aesthetic balance of large complex images when his eyes can only see a fraction of the image, he confessed, "The hard part is keeping the paper flat after I put a wash of ink on it, like in *Lightning* and *Adashino*. When the ink dries, you must work with the paper to keep it from rippling." He clearly perfected this technique, for the following year he began working on his magnum opus, the seventeen-feet-wide *Big Bang: E = mc²*. It spans six scrolls, each panel five feet, eleven inches in height.

Iwasaki worked up to this ability by applying his brushed calligraphy skills to scripture-copying practice, which he began with focused intent when he was sixty-three. Gratitude and concern for the well-being of all flowed through his heart into the tip of his brush as he copied the *Heart Sutra* nearly two thousand times. He affirmed the merit that accrues through copying sutras, which activates a peaceful, calm, and expansive heart that easily attunes to others. Iwasaki experienced increasing joy and warmth as a result of his scripture-copying practice, enabling him to have more harmonious interactions, to engage in transformative listening, and to make wiser choices. Nonetheless, having completed this prodigious spiritual act of

compassion, a longing stirred in him as he thought, "There must be more." Keenly aware of the suffering in his midst and the diminishing numbers of people who learn Buddhist teachings through daily activity, he channeled the intimacy he cultivated with the text into an innovative way to make the teachings visually accessible.[29]

So it was, at the age of seventy, Iwasaki began to shape the characters of the scripture into images that convey the meaning of the scripture. In so doing, he extended the contemplative practice of scripture copying and launched the tradition of tiny-character painting in a new direction.[30] Technically called *saimitsu* (細密), the tiny characters can create the effect of a fluid line. Regular-sized characters in scripture copying are usually about fifteen millimeters. *Saimitsu*

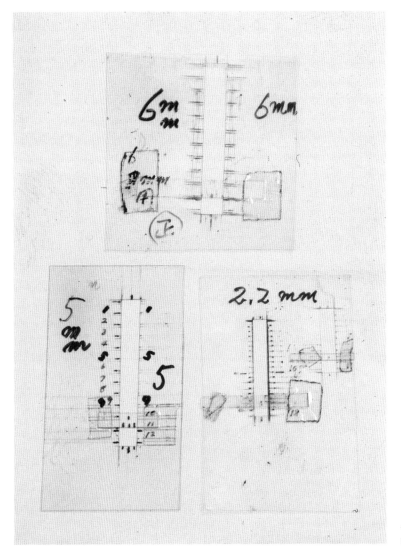

Tiny-character templates.

tiny-characters are five millimeters or less. Iwasaki favored two-, two-and-a-half-, and three-millimeter characters for most of his paintings. He made templates with millimeter markings to ensure he maintained uniform size. His modesty was palpable as he chuckled about a tedious quandary that challenged him with each painting. "I can't finish the sutra before I finish the image, and I can't finish the image before I finish the sutra!" So before he even put brush to paper, he precisely calculated the size of each character he would need to make an image. The numerous measurements involved were dauntingly intricate, and his success in the compositions revealed the benefit of his scientific training to be accurate with details and calculations. Calling himself a "Sunday carpenter," he created a magnifying glass holder to help him see as he brushed each of the carefully calculated strokes. Having spent much of his life looking through microscopes, he was at home working in a miniature scale that required a magnifying glass. Nonetheless, the steadiness of hand required to do profuse calligraphic brushstrokes with such precision is stunning. Sharing his inner experience, he disclosed to me, "Writing in tiny characters, I enter an environment where there are just characters. It is like zazen."

Across several dozen visits together, I was able to hear and observe many of the details concerning Iwasaki's process for preparing himself to paint. He would generate a sacred space by ritualizing each act, because for him, painting was a contemplative practice with numinous meaning and bounteous significance. He carefully attended to all the senses. Sitting at the low table with a straight spine, relaxed and

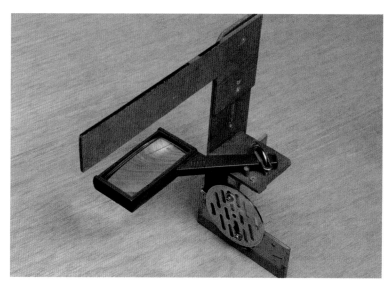

Magnifying
glass holder.

Dewdrop: Buddha's Tear detail.

grounded in his *hara* (abdominal center), he placed cherished prayer beads on his left wrist and lit incense.[31] He would breathe deeply and do a *gasshō*, palms together in prayer, respectfully in a slight bow. With the aroma of incense wafting in the air, he chanted the *Heart Sutra*, focusing his mind.

Next, he meditatively prepared the ink. He carried the practice of using pure water to make *sumi* (墨) ink to a profound level. Each year, at dawn of the seventh day of the seventh month, Iwasaki collected dewdrops from lotuses, whose purity symbolizes enlightenment. This was his personal ritual to celebrate Tanabata, the star festival of cosmic love. This is the one day that celestial conditions permit two lovers—otherwise separated by the Milky Way—to meet. That Iwasaki went to such efforts to gather lotus dew for his ink on this day reveals he wanted to infuse his brush with a love powerful enough to endure and connect across cosmic spans. He realized that connecting in love is liberating.

Iwasaki using his homemade template and magnifying glass stand to paint.

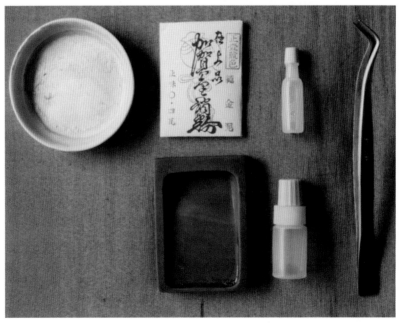

Materials for painting in pure gold ink: porcelain mixing bowl, 24k gold powder, ink stone, two bottles of fluids, and a tweezer.

After harvesting the dewdrops, he preserved them for use throughout the year by freezing them in small containers. He also harvested sacred water, including from Kyoto's Kiyomizu Temple waterfall, water from a well opened by Shingon Master Kūkai, and water from a river on the sacred mountain protecting Kyoto's northeast flank, Mount Hiei. When preparing to paint, he would pour a few drops of water—whether lotus dew or sacred water—into a shallow reservoir of a stone that had been carved and polished expressly to serve the calligrapher. Holding a stick of solid ink in his hands, he pressed down on it and drew droplets up from the pooled water to the silken smooth flat surface of the stone. Gentle, slow, rhythmic rubbing and light pressure would yield a fine solution as his mind merged more deeply with the ink. The power of steady confidence and strength made smooth, even ink and helped him liquesce any inflexibility that might have crept into his mind.

Magnifying glass stand and template in place, he chose which brush to use, often one with ten hairs, sometimes as few as three. Each stroke renewed his awareness that if he were to err even one character, the whole painting would be ruined. He could not go back and fix or change a single stroke like he could with oils. Ink painting is an art that thrives on the present moment. Moreover, for him, each brushstroke was a prayer for healing. Therefore, if he had bad dreams the night before—intimating the traumas of war his art was helping him transform into healing—he admitted it was hard for him to work on his paintings for a few days.

In addition to *sumi* ink, he also painted with gold and silver, which are notoriously recalcitrant substances that resist being tamed into delicate lines. When he needed color, he used pastels, prominent in *Mandala of Evolution*. Occasionally he used a collage technique, notably for the eight-headed dragon in the center of the black hole in *Big Bang: E = mc²*. Impasto was employed in *Hōryū-ji Pagoda*. Iwasaki commanded a wide range of techniques to paint the staggering scope of subjects he engaged, from traditional Buddhist iconography to current themes in astrophysics, quantum physics, and biology; from intricate representational images that mirror photographic accuracy to classical Japanese-style ink paintings.

Iwasaki had two different types of traditional East Asian seals of authenticity, uniquely carved seals applied with cinnabar paste. Sometimes he imprinted just one, and, especially for larger works, he pressed both seals on the painting. One seal is carved with his

Signature and Seal:
萬里淨書 (*Banri Jōsho*), "Everywhere Pure Writing."

given name: 岩崎常夫 (Iwasaki Tsuneo). The other seal indicates that he is a recognized artist, and it is carved with his artist name: 萬里 (Banri). The most literal interpretation of his name is "ten thousand leagues" (a league is 2.44 miles), a traditional number to suggest vast distances. It fittingly heralds the distances he traveled in his mind to do his painting and perhaps presages the reach of his artistic vision. A more poetic interpretation is "hometowns everywhere," suggesting how he felt at home in the world, connected to all as family. In addition to stamping a seal on each painting, he brushed in fluid *sōsho* script: 萬里淨書 (*Banri Jōsho*), "Everywhere Pure Writing." It is a ritualized phrase expressing that he, Banri, wrote the *Heart Sutra* with respect and gratitude. For him, brushing these characters was an expression of his being. He revealed to me that, when he painted the *Heart Sutra*, any sense of isolation melted away, opening up a seamless relationship with the brush, ink, paper, image, and spacetime. The depth and purity of his gratitude and respect vested him in a mission to embody the teachings of the *Heart Sutra*. Attentive to the needs of his body, he related to me that after working, he would breathe deeply and massage his eyes.

Iwasaki's engagement with the *Heart Sutra* deepened as he chanted it at each of the 276 temples included in the five pilgrimage routes he traversed from ages seventy-one to eighty-three. Spanning twelve years and 4,800 kilometers, he studied the histories of the temples and pilgrimage routes, which date back as early as the eighth century. The commitment of energy, time, and resources to arrange for and carry out each of these pilgrimages expanded Iwasaki's view of the cosmos from the inside out.

Iwasaki's voracious curiosity and fearlessness to pursue understanding drove him to ask enormous questions. As a scientist, he honed his powers of observation by asking, "What is happening? What can be verified?" As a Buddhist he asked, "How do we stop suffering? What is compassionate activity?" After a lifetime of researching and experiencing, his paintings are the answers he found. With the meticulous precision of a scientist, the aesthetics of a refined Japanese artist, and the heart of a wise and compassionate Buddhist, Iwasaki employed creative, perceptive, and meditative mind

to integrate his streams of insight into nondual wisdom with scientific perspectives on phenomenal reality.[32] His presence is palpable in each stroke, as is the scientist's care for intricate detail and precision. Enhancing each other, they manifest his focused embodiment and commitment to conscious awareness of the fullness of each moment. Having cultivated these qualities throughout his life and honed them over extended pilgrimages, Iwasaki saw, tasted, touched, heard, and smelled ultimate meaning in what he perceived. This is the key to how his paintings draw you into a sensorium and reveal that the meaning we seek is in the world around us.

Even after thirty years of doing calligraphy, painting, and studying Buddhist teachings, he explicitly articulated that he did not consider himself a "calligrapher, painter, nor Buddhist scholar." He stressed that the quality of writing was not important to him because his effort was simply about sharing Buddhist teachings through pictures.

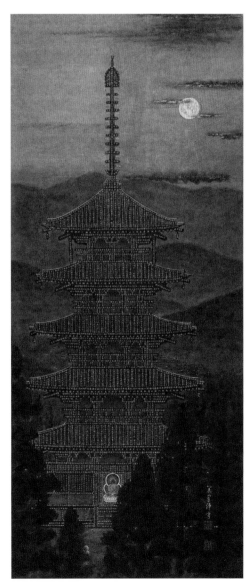

I hold my palms together with a sense there is some awakened power guiding me. When I paint, it feels like I am on a pilgrimage, "Traveling Two Together."[33] It's like my hands are being guided and inspiration for ideas comes to me in dreams and other types of mysterious experiences. Doing this connects me to all beings.

Painting as a meditation, he showed us what the world looks like from the perspective of someone who experiences being an integral part of an interdependent whole. His art models for us how to look at a dewdrop and see the universe.

OPENING THE HEART OF COMPASSION

Amid the bustling of the Chūnichi Cultural Center in Nagoya, Iwasaki and I had another *Ichi go. Ichi e.* moment that intensified our relationship. We stopped for a cup of tea after listening to one of Matsubara's lectures on

Full Moon Shines on Pagoda (121 x 51.5 cm)

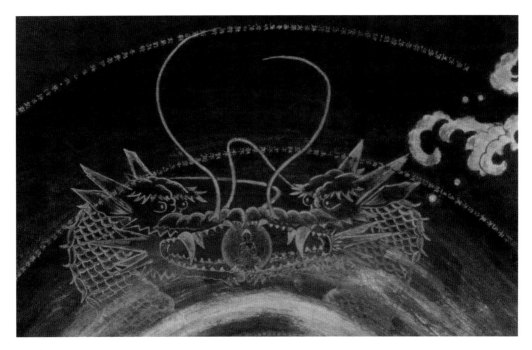

Radiating Pearl, detail of gold and silver version.

Zen. During that memorable and scintillating conversation, I had a taste of the inner workings of his mind. Jumping right in, he asked me—as if it were a common question—how I would paint a black hole. I had no idea. The velocity of his imagination and the ebullience of his curious delight in the unknown were in full force. Our discussion veered into an exploration of the significance and meaning of the *Heart Sutra*'s most famous line, "Form is emptiness; emptiness is form." With a sense of vulnerability that often attends sharing a secret, we confessed to each other that we thought this Buddhist teaching was elegantly expressed in the scientific formulation $E = mc^2$. Animated with joy at the discovery we shared this thought, a secure conduit opened, ever after enabling us to communicate with a sublime sense of mutual trust and understanding.

Based on our relationship and drawing deeply from the well of explanations Iwasaki shared with me, I composed meditations on his visual commentaries of the *Heart Sutra*. Where we had not explicitly conversed about a particular point, I extrapolated principles and insights gained from our conversations and integrated them into my analysis of the paintings. The expertise of a number of scientists— an evolutionary biologist, a biochemist, a neuroscientist, a quantum physicist, some astrophysicists, and a mathematical cosmologist— helped me fathom the significance of specific phenomena featured in Iwasaki's paintings. The eight themes I have selected to focus on in part 2 are interwoven through Iwasaki's oeuvre. Though not actually

divisible or separable from one another, each theme is an animating principle of Iwasaki's scientifically informed Buddhist vision of qualities of healing: interbeing, flowing, nurturing, forgiving, offering, awakening, playing, and flourishing.

In addition to these dynamic activities that weave together his vision of healing, Iwasaki quietly envisioned a world in which his painted prayers would be a healing balm. Capturing subtle pulses in the currents of our post–World War II society, Iwasaki's art makes meaning out of microscopic, everyday, and cosmic dimensions of experience. Infused with a sense of adventure and promise, he charts an evocative and nuanced course through realms opened up by scientific discoveries that change who we think we are, where we think we are, and what we think is important for survival. Rather than signify separate entities, Iwasaki's paintings beckon us to focus on process, movements, shared energy, transformation, and the beauty of the present. Iwasaki's art expresses the idea that we are invisibly connected and models how to feel the intangible emptiness of all form. Educating the senses, his art directs the mind by lifting into high relief what civilization might do to harmonize tensions. His art offers imaginative visions to inspire ways to solve problems that are not yet solved by direct cognition. Continuing in the Japanese Buddhist art stream, Iwasaki gives form to our ultimate connections. And in so doing, he transforms the world in which we live.[34]

I encourage you to explore creative ways to journey through the paintings. I raise questions and offer my poems and my translations of poems by Iwasaki, Rennyō,

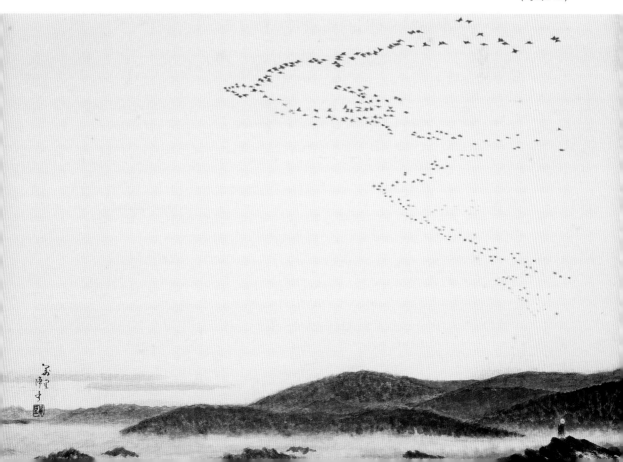

Migrating Birds
(115 x 70 cm)

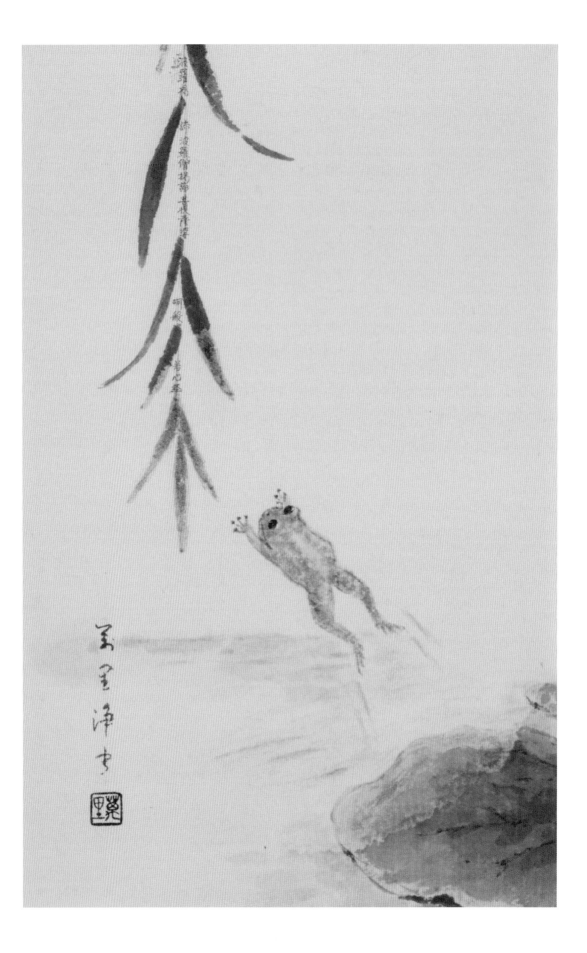

and Saigyō you might ponder along the way. Sometimes you might approach a painting from a state of repose, as in a daydream, with the image floating in and out of discursive and deliberate focus. Feel the rhythm of a painting. Some dart and soar. Some slow down and stretch spacetime, magnifying your perception. Experiment with your vision. Notice the tempo and mood change with each view. While engaged with analytical mind, contemplate the significance of a specific image. Reflect on the merit and meaning of using the same words to form images as small as a quark and as big as the cosmos. What insights might be harvested from underlying metaphysical implications? Investigate the ethical ramifications implicit in each image. Perhaps test the healing power of the *Heart Sutra* teachings in your own life.

As you go, imagine what you would form with a palette of *Heart Sutra* characters. Discover the way the paintings open your heart of compassion.

OPPOSITE:
Frog and Willow (76 x 17 cm) detail.

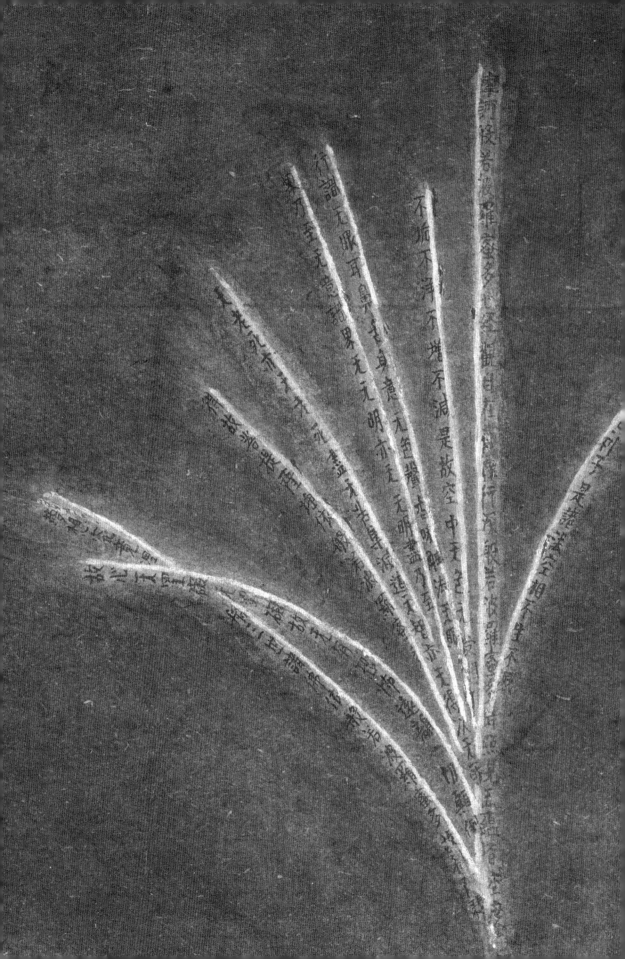

SEEING THE WISDOM
OF COMPASSION

*My purpose for tiny-character sutra copying
paintings is for you to see the teachings of
the Buddha, to see the Buddha. I am deeply
grateful to dwell in the heart of the sutra. Also,
contemporary people who have lost themselves
in busy-ness and whose hearts are dissolute,
I pray they feel some succor and compassion
when they look at these paintings.*[35]

—IWASAKI TSUNEO

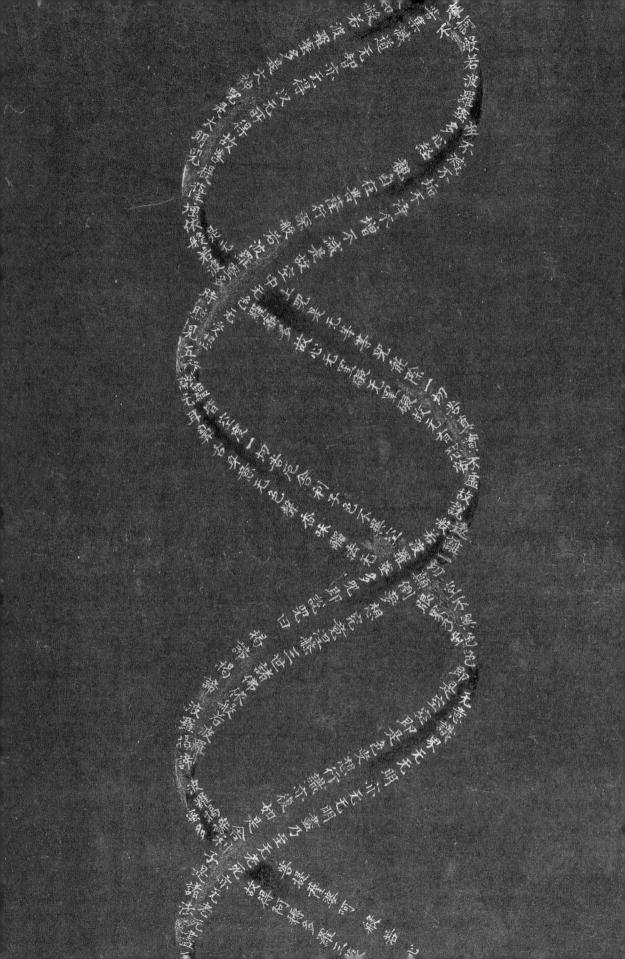

DNA (30 x 27 cm)

Who am I?

Magnifying a double helix, Iwasaki makes the seemingly solid form dissolve into the shimmering gold characters of the *Heart Sutra,* a code to wisdom that when embodied generates myriad forms of compassionate activity. The midnight-blue background evokes deep space, placing DNA in the expanded context of the cosmos. Iwasaki shows the emptiness of DNA by portraying it as a delicately porous pattern shaded by strokes of dark ink that evoke volume but not solidity. Following the stream of characters draws the eye into the swirling motion of the helix as it revolves and interlaces. In the manner of Fa-tsang's golden lion—the lion statue, discussed in the introduction, whose shape indicates form even as its malleable substance represents emptiness—the golden DNA provides a visual metaphor for the insubstantiality and impermanence of the scientific image and, by extension, our conventional perception of reality.

All life forms as we know them depend upon DNA, and each copy of DNA contains essential information for a life form. Cells have been transmitting their genetic code on strands of DNA for over three billion years. The information in DNA that is activated, transmitted, and copied significantly determines with what forms and sensations one can experience life.[36] The uniqueness of each organism's DNA enables it to experience life in richly distinct ways, strengthening our diversely creative network of being. DNA is also a portal into the past, enabling one to connect with those who helped form and inform one's cells. Though not able to portend with detailed accuracy, DNA can give a glimpse of one's future. Analysis of a fragment can exonerate an innocent person or convict a criminal. DNA can even help people discover and recover connections.

Demonstrating the precision of Iwasaki's observations, his

painting of DNA conveys the asymmetry of the spiral in the helixes. He does not, however, include the sequence of base pairs, which is what makes us unique. He shared with me that his choice to paint only the backbone of the two DNA strands expressed his concern to highlight the commonality of forms of life. Without the base pairs, the artist evokes a general image of DNA, from bacteria to blue whales. Iwasaki's *DNA* invites us to imagine it as that of a fly, a flower, an endangered tiger, a cancer cell, or our mother.

Venturing further into the dynamics of form and emptiness, Iwasaki reveals keen insight by painting a bold claim that imbibes Fa-tsang's commentary on the *Heart Sutra*. "The *Heart Sutra* is a great torch that lights the darkest road, a swift boat that ferries us across the sea of suffering."[37] To symbolize the shore of suffering—samsara—he painted a darkened muddy line in the lower right corner. To symbolize the other shore of enlightenment—nirvana—he painted a luminous gold line in the upper left corner. Iwasaki told me that painting DNA between these shores was a way to see our body as a vehicle to journey from suffering to enlightenment. I was stunned by his cellular affirmation of our bodily form. Although many cast the body as the source of attachments and suffering, Iwasaki proclaims with his *Heart-Sutra*-coded DNA that the six perfections of generosity, morality, forbearance, vigor, meditation, and wisdom must be embodied. Wisdom needs a form to bring the healing power of compassion to life.

Iwasaki merges the ecological vision of a thoroughly interrelated biosphere with the Buddhist teaching of interrelatedness. Whether one applies a scientific understanding of biological processes or a Buddhist understanding of emptiness, DNA is interconnected with every condition that affects its activity. DNA reveals a profound commonality that, in Buddhist terms, underlies empathy and merits compassion. Pointing beyond socially constructed distinctions that justify neglect, exploitation, and harm, Iwasaki's work is ethical in thrust.

His *DNA* painting heralds what living beings share. DNA is a record of interrelatedness that spans billions of years and connects all life forms; it provides evidence for the fact that we are not independent entities. Humans share DNA with ancient bacteria, grains of rice, cherry trees, butterflies, baboons, and frogs. Each of our cells contain the code of an interrelated web of life. This biological phenomenon is consonant with the teaching of interbeing voiced in the *Heart Sutra*. While in other paintings Iwasaki evinces the wisdom of the *Heart Sutra* with rushing water, swirling stars, and bursts of light,

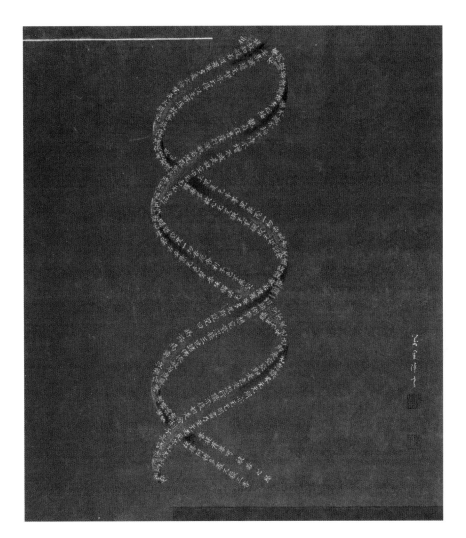

by creating DNA out of the *Heart Sutra*, Iwasaki reveals a compelling nuance of his vision. With DNA being central for a code to life and the *Heart Sutra* a powerful code to enlightenment, Iwasaki proclaims that the code of enlightening wisdom sung in the scripture is embedded in the very code of life, embodied in every living cell.[38] His *Heart Sutra* DNA denotes the biological dimension of interbeing as it affirms that the essence of enlightened wisdom is a cellular reality and that the transmission of wisdom is a fundamental life activity. We are encoded with Buddha's DNA.

Which genes will be expressed, however, depends on numerous causes, conditions, and actions in the present moment. Iwasaki's oeuvre presents us with his journey of exploring these questions: How do we fully express our Buddha DNA? How do we activate the code of enlightenment?

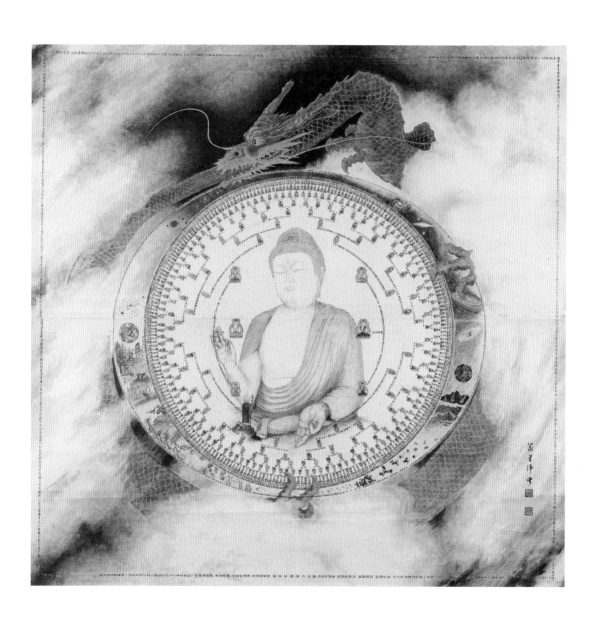

MANDALA OF EVOLUTION

(180 x 180 cm)

Who is in my family?

Descendent of lightning,
Hydrogen atoms from the dawn of the universe aerate my lungs.
Iron traces of stellar explosions course through my veins.
The regenerative power of starfish fuels my creativity.
The adventurous courage of amphibians quickens my gait.

Begat from paramecium and gingko trees,
My great, great grandfather an amoeba,
My grandmother a cherry blossom.
I will become rain.

Iwasaki spent two years painting *Mandala of Evolution*, his vision
of enlightened reality. Inquiring into the causes and conditions of
dependent co-arising and the nature of emptiness, he became inspired
by the question, "Who are my ancestors?" This mandala is his answer.
As he explained to me, he begins with himself, or any viewer of
the painting, represented as a contemplative pilgrim. Each father is
represented as a white Buddha and each mother as a red Buddha.
The sum of one set of parents, two sets of grandparents, four sets
of great-grandparents, and continuing back for thirty generations,
reaches well more than a billion. Such a figure brings home the point
that we are not just metaphorically one big family; we are biologically
interrelated. This sublime and expansive genealogical tree spreads out
to the perimeter of the circle in a continuous extension that includes
asteroids, protein molecules, amoeba, paramecium, mollusks, starfish,
amphibians, tree ferns, dinosaurs, marsupials, conifers, primates, and
cherry blossoms. He shows our sun swelling into a red giant, which

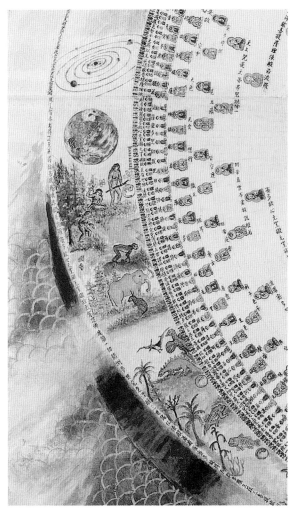

Amphibians, dinosaurs, ginkgo, primates, cherry blossoms, solar system (*Mandala of Evolution* detail).

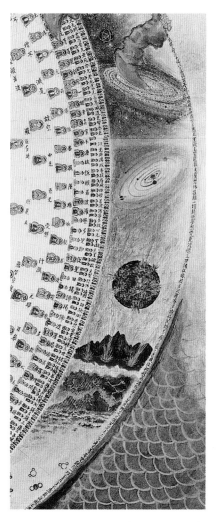

Complex atoms, asteroids, lightning, molecules (*Mandala of Evolution* detail).

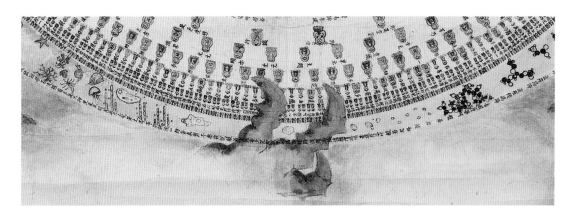

Complex molecules, amoeba, paramecium, seaweed, mollusks, starfish (*Mandala of Evolution* detail).

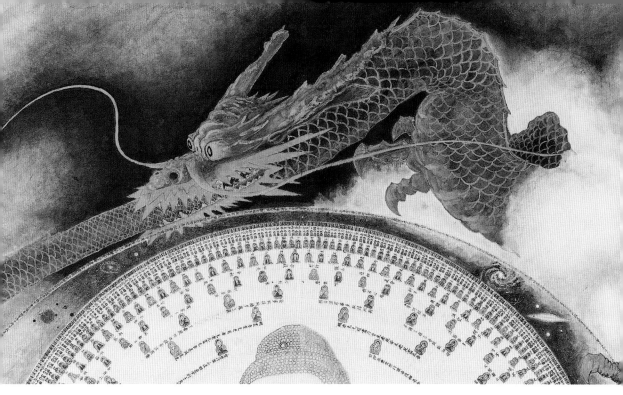

Red giant, planetary nebula, hydrogen, helium (*Mandala of Evolution* detail).

eventually becomes a planetary nebula, releasing energy for new forms, including hydrogen atoms that might one day form stars.

Beginning one calligraphic rendering of the *Heart Sutra* by the main mother Buddha and another by the main father Buddha, he weaves the sutra through all the images in the mandala to illustrate all flowing with the same energy. To emphasize that "form is emptiness; emptiness is form," Iwasaki poignantly places this text on each side of the contemplative viewer's parents, bringing home the point that one is born from *form and emptiness*. All are the progeny of Buddhas. Iwasaki disavows the idea, stated in some Buddhist scriptures, that only male bodies can be enlightened or gain rebirth in the Pure Land. In depicting each mother as a red Buddha, he places hundreds of female Buddhas under the compassionate gaze of Amida Buddha. In designing his mandala of enlightened reality this way, Iwasaki exhibits nondual wisdom and underscores the ethical importance of understanding the nature of emptiness and form. He signals the centrality of this wisdom by placing this teaching on a horizontal axis in the middle of the painting, the only horizontal words in a sea of characters swirling in circular motion. To convey that energy does not necessarily flow in a linear and singular direction, he interlaces the *Heart Sutra* streaming both clockwise and counterclockwise.

In quiet outline form, Amida Buddha's presence at the center of the mandala imparts warmth. Among Buddhas, Amida is easy to turn

SEEING THE WISDOM OF COMPASSION

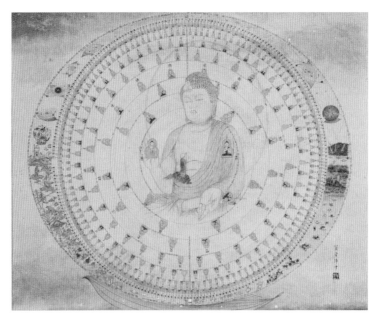

Neo-Mandala
(80 x 70 cm)

to for support, just as a child turns to a parent. Praise to Amida flows graciously across the lips of those who are touched by the benevolence of this Buddha. As a scientist, Iwasaki selects Amida for the center of his *Mandala of Evolution*, because this Buddha is the Buddha of Infinite Light. Light is energy.

With animated delight, Iwasaki showed me a newspaper clipping that drove him to redo the entire thirty-five-square-foot painting. He had painted the whole mandala resting on a leaf suspended in space, but upon reading the newspaper article about the Greek Ouroboros, the symbol of infinity and perfection, he was driven to intensify the dynamic flow of energy in the painting. Transforming the Ouroboros symbol of a snake, he encircles the mandala with a golden adamantine dragon. Dragons are revered and respected as powerful protectors of the Dharma, the healing way of wisdom and compassion. The dragon swallowing its own tail illustrates the *Heart Sutra* teaching that there is no beginning or end. No birth, no death. Transformation keeps happening, weaving us all together in a cosmic egg, swirling in a womb of compassion.

Sharing his reflections about this painting with me, Iwasaki expressed how it is hard to find a difference between people, animals, and plants, because we are all just various groupings of carbon, hydrogen, oxygen, calcium, iron, and nitrogen. He then asked the question, "What rituals support the healing and enlightenment of your ancestors when your ancestors are the whole universe?"

"Form is emptiness. Emptiness is form." (*Mandala of Evolution* detail).

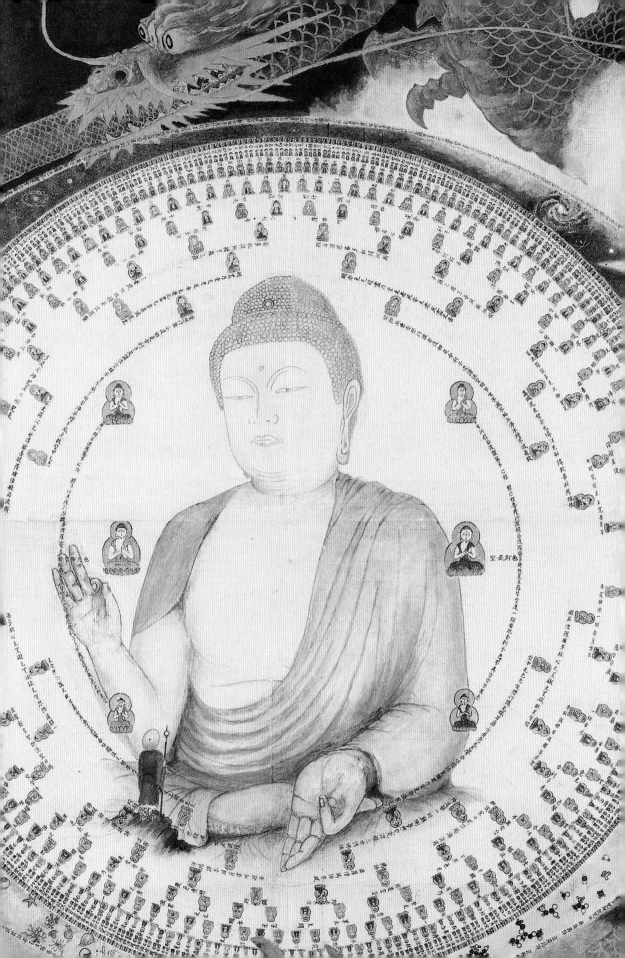

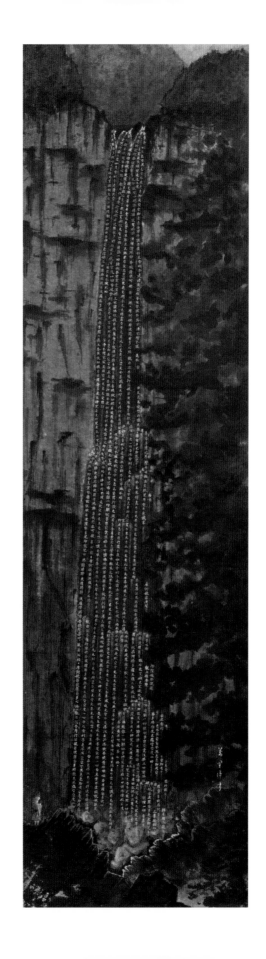

NACHI WATERFALL (96 x 28 cm, 1990)

How might I move as fluidly as water?

Iwasaki related to me how, on the famous Saigoku Pilgrimage, which passes by the Nachi Waterfall, he had felt the power of the gushing water as he stood in front of it.[39] It inspired him to share this pilgrimage experience by painting a vigorous stream falling onto rocks and splashing into waves, droplets, and clouds of spray. The dramatic depiction shows how streams of energy, ever in flux, form the phenomenal world as different levels of fluidity dancing before our eyes. This visual sutra of water flowing freely illustrates impermanence, while a tiny human figure gazing on the spectacle conveys that humans share in this transience. It is often hard, though, to perceive ourselves as liquid as water. Water moves affably with current conditions, streaming along without umbrage about whence it came, nor fear for where it will go. Iwasaki wished his flowing *Heart Sutra* painting would help people experience the flow of wisdom one might feel gazing at a waterfall deep in the mountains.

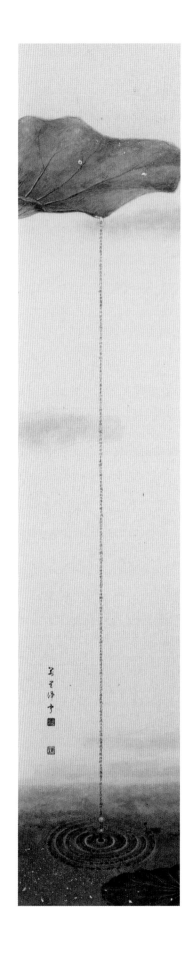

DEWDROP: BUDDHA'S TEAR

(100 x 17 cm)

What ripples am I setting in motion?

> A pearl of dew plops
> A muddy pond awakens
> Ripples flow on and on

A dewdrop is the quintessence of evanescent beauty and interrelatedness: one moment glistening with the sun's brilliant light, the next moment united with the murky pond. Perhaps we are drawn to the dewdrop's fearless elegance because we share in the journey of transforming water, our lifeblood. Likewise, just as each drop of dew generates ripples across the far reaches of the pond's expanse, each of our thoughts and actions begets cascades of emanations that extend beyond our control and consciousness. Not knowing what our actions will cause, yet knowing their effects will stretch deep into the cosmos, each choice is significant. Iwasaki's choice to imbue the undulations of a dewdrop with the *Heart Sutra* is an invitation to consider how to radiate ripples that alleviate suffering wherever we go.

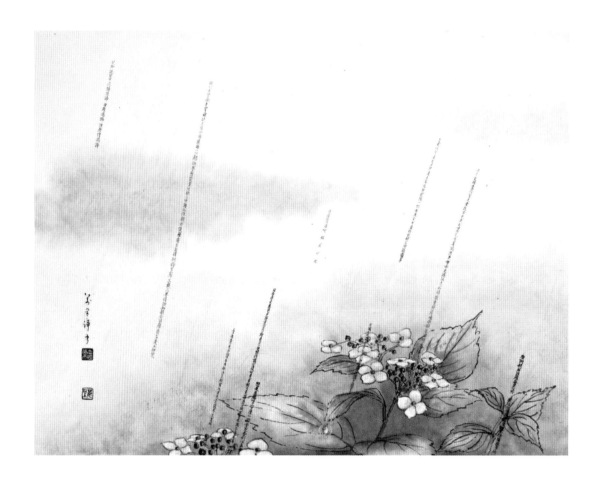

RAINING (41 x 31 cm)

What do my teardrops nurse?

 Celestial droplets,
 Pattering of emptiness,
 Rain nurses flowers.

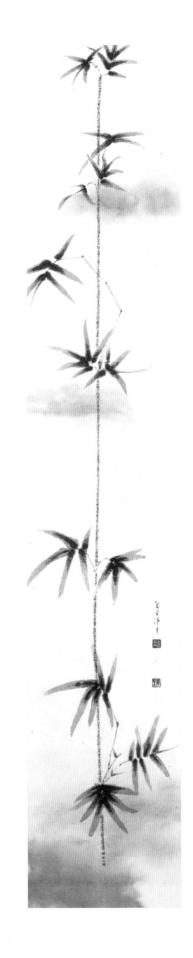

BAMBOO (110 x 28 cm)

When is bowing an act of strength?

Nature teaches the heart to see.
Ever green,
Bamboo teaches the heart
To be strong,
To bend in the wind.

How can you comprehend sutras
If you do not understand
The supple strength of bamboo?

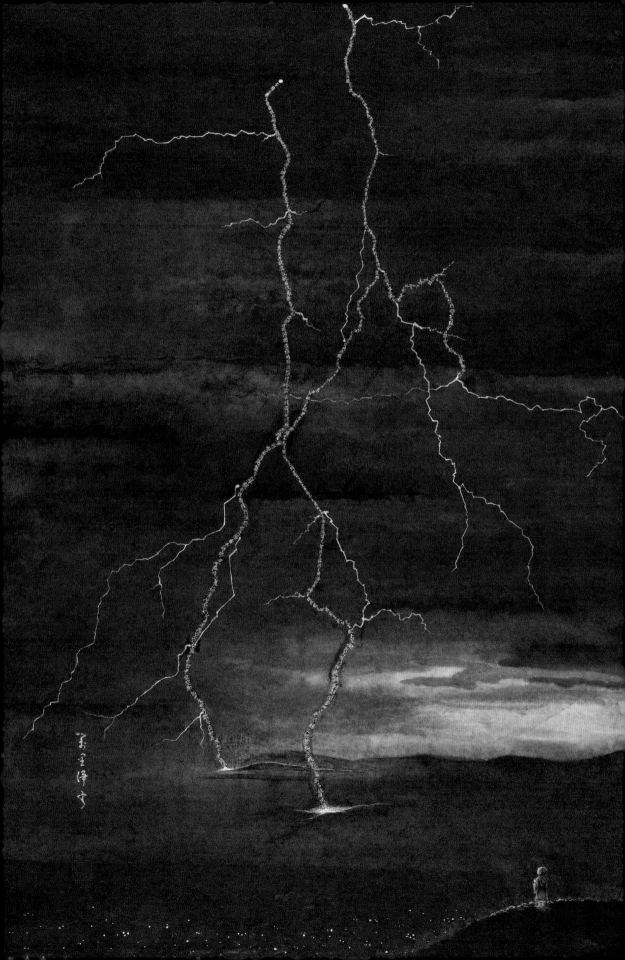

LIGHTNING (84 x 61 cm)

What helps me restore balance?

The sky rumbles as storm clouds gather. Dark clouds backdrop
cloud-to-ground lightning bolts—potent expressions of
ephemerality whose powerful currents connect the earth and
sky. In their average duration of thirty microseconds, they
can discharge a billion volts of electricity to restore, however
fleetingly, balance in the charges of the atmosphere. The
causes and conditions for a lightning bolt to strike are specific
and rapidly changing. They wield unpredictable, concentrated
force. Indeed, it may have been a bolt of lightning that, striking
complex molecules in a primordial tide pool, triggered the
formation of life on Earth, positing us in the lineage of the
electric sky.

The contemplative figure in the lower right corner reflects
how humans also experience conditions changing quickly. Many
among us have experienced stentorian cracks of thunder rupture
our hearts. A blinding flash of stunning force sears into our mind
horrific images we cannot unsee—much less undo—sundering
the fabric of life. Suffering can be a fuel that helps one burn
through to a deeper consciousness, where raw emotions churn
and delusions combust. Those with the wisdom and fortitude to
face this suffering clearly will find a path to awareness appearing
before them. Others have come through this way before, evident in
the traces of pain deep in their eyes, the way they gaze at the world
around them with a knowing tenderness, their quiet strength, and
a peace that emanates from beneath the storms on the surface of
reality.

If, however, one does not awaken to wisdom when lightning
strikes, the torrid suffering of delusion, hatred, and attachment will

continue to char oneself and others, rather than be transmuted into the balanced mind of compassion. In rendering lightning with the characters of the *Heart Sutra*, Iwasaki not only directs attention to the fluctuating and interdependent nature of causes and conditions but also considers the consequences of not awakening to our reality.

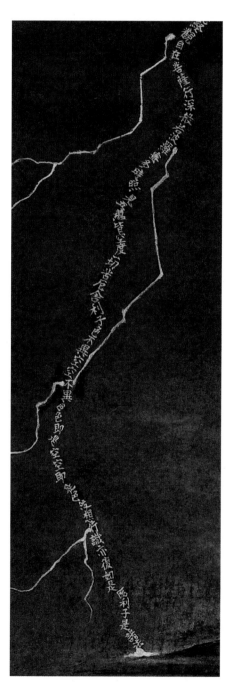

Lightning detail.

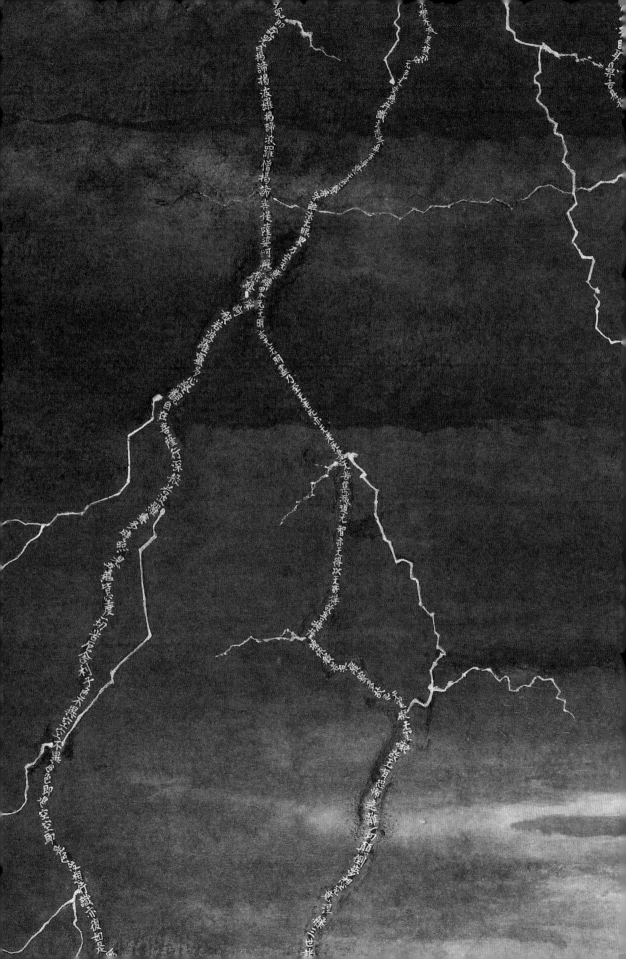

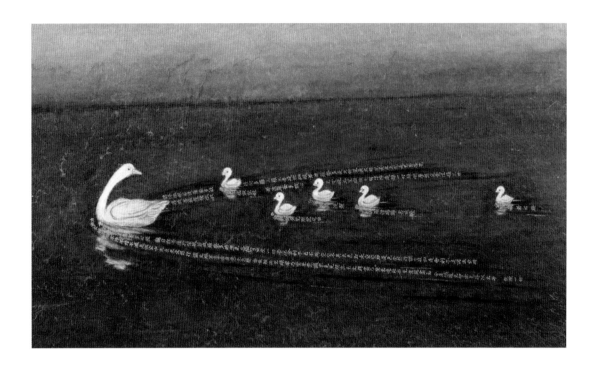

COMPASSION RIPPLES (40 x 26 cm, 1993)

How am I held in love?

Cradled in blue, a brood of ducklings swims in the protective wake of *Heart Sutra* ripples that their mother radiates as she looks lovingly aft. Embracing her young and vulnerable charges, she quells their fears and tends to their growth. In *Compassion Ripples*, Iwasaki shows us what a compassionate relationship between parent and child looks like. Iwasaki ached that not everyone knows such compassion. He penned his pain, "Saddened to live in a time when people are lost and in an age where parents kill children and children kill parents." This painting is a prayer for compassion. Seeds of compassion are watered with each intimate connection. Compassion generates inspiring and empowering energy. Parents embody compassion when they nurture compassion in their children. Suffering ceases when we experience the universe as a vast interdependent web where we are all parents and we are all children.

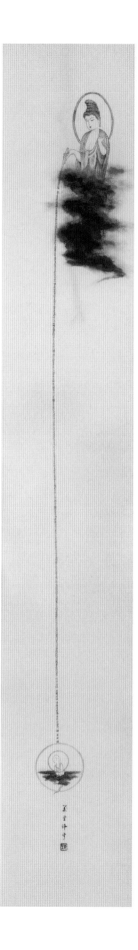

MOTHER OF COMPASSION

(115 x 20 cm)

How do I nurture compassion?

Hear crying.
Pour healing.
Dissolve delusion.
Embrace
Beings in wombs.

Heart Sutra medicine—
Take as needed.

A mother of compassion is one whose compassion is liberated from
the shackles of delusion. Through nondual wisdom, she perceives
the five streams of body, heart, and mind as empty of intrinsic reality,
as boundless. Hearing the cries of the world, nothing obstructs her
from embracing each being in a womb of compassion. In taking form,
we activate forces of compassion. *Mother of Compassion* freely pours
Heart Sutra streams, a medicine to eradicate ignorance and alleviate
suffering.

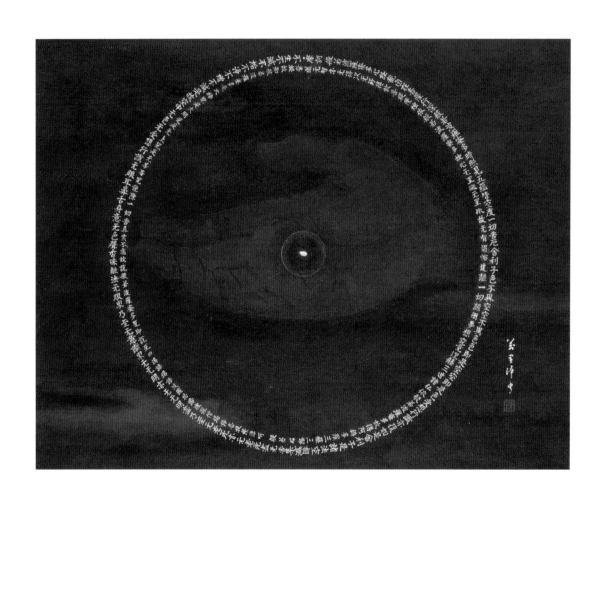

GRAIN OF RICE (41 x 32 cm)

What nourishes me?

Remembering how, during the severe food rationing of World War II, his mother said to care for each grain of rice, Iwasaki depicts her gently curving hand, tenderly holding a single grain of rice. He paints a *Heart Sutra* corona around her diaphanous hand, inviting us to feel reverence for the treasure on which the circle of life depends.

We can also see the hand as our own, reminding us to nurture ourselves and care for all things that support life. Contemplating the innumerable causes and conditions required to bring one grain of rice to our hand conjures images of other hands cultivating and harvesting the rice plant, earth teeming with nutrients, clouds gathering, rain falling, and sun warming. The hand floating in a sea of darkness spurs us to extend our reverie to the cosmic conditions that beget this one grain of rice: the hydrogen atoms that formed some 13.5 billion years ago, the intense heat of star explosions that formed minerals, and the gravity that keeps our planet in orbit around a sun that provides just the right temperatures required for the rice plant to grow. To reap the life-sustaining nutrients of the grain of rice, we depend on multitudes of microorganisms to digest our food as we, in turn, feed them. Pondering the robust microbiomes in our bodies strengthens awareness of interbeing and removes notions of an autonomous self. Yet being part of the greater whole, our food is now subject to the greed and delusion being released into the air, water, and soil. When we send these poisons into our environment and our agriculture, we plant the seeds of disease and cancer in our own food sources. Some, too, will be harvested by our progeny. Assuring the rice we plant for future generations is not toxic is a compassionate response to our boundlessness.

To face the totality of one grain of rice intensifies our ability to see the entire universe present as the conditions of its existence. Then each

bite of rice evokes the refining grace of gratitude for the universe that nurtures us in a vast cycle of nourishment. To sense this is to sense the wisdom of emptiness, to be aware that our everyday experiences are ultimate. In fathoming a rice grain's fullness, we can taste complete enlightenment.

OPPOSITE:
Grain of Rice detail.

般若波羅蜜多是大神咒是大明咒是無上咒是無等等咒能除一切苦真實不虛故說般若波羅蜜多咒即說咒曰揭諦揭諦波羅揭諦

不生不滅不垢不淨不增不減是故空中無色無受想行識無眼耳鼻舌身意無色聲香味觸法無眼界乃至無意識界無無明亦

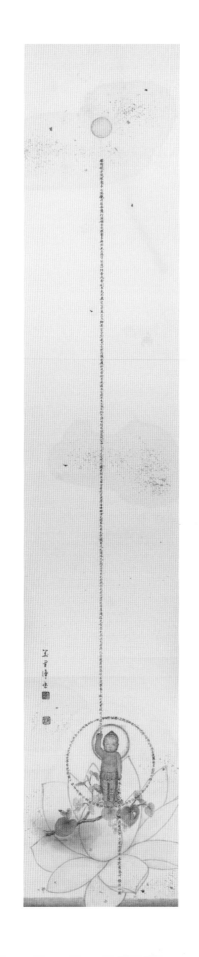

BABY BUDDHA (115 x 20 cm)

How do I give birth to wisdom?

Shadows of bodies
Seared on stone steps that sunny
Morning in Hiroshima.

Sentinel at the Peace Memorial
A baby Buddha
Remains in radioactive rubble.

How many Buddhas must die
Before we learn
Every birth is
The birth of a Buddha?

Celebrating the birth of a buddha with the *Heart Sutra* is Iwasaki's gentle way of encouraging all who are born to dissolve poisonous fears and respond with compassion to the cries of the world. The exigency of our collective need for compassion is on display at the Hiroshima Peace Memorial Museum: A baby buddha statue found in the scorched remains of the atomic bombing. The lotus blossom from which the baby buddha arises and full moon shining above are both symbols of enlightenment, evincing the enlightenment that comes with living the *Heart Sutra* teachings. Chanting the mantra at the end of the sutra "creates the womb from which we are reborn as buddhas."[40]

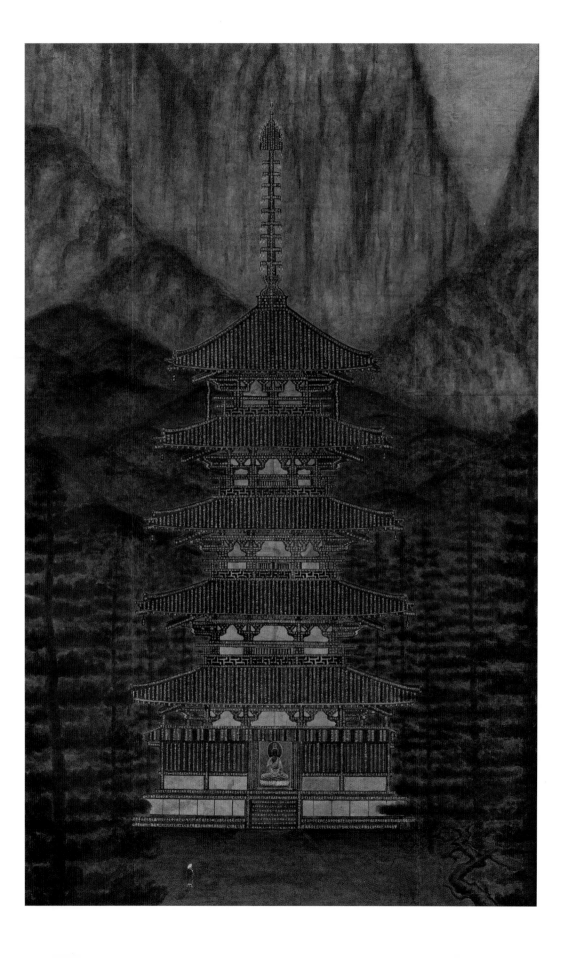

PILGRIMAGE TO A PAGODA

(220 x 140 cm)

Where do I go for healing?

Pagodas are an East Asian architectural variation of the Indian stupa, a dome-shaped reliquary for the Buddha. The five-tiered pagoda of Hōryū-ji (法隆寺) temple has towered above the landscape of Nara for nearly 1,400 years. It is one of the oldest wooden buildings in the world. Prince Shōtoku (572–622) commissioned the original construction in 607 C.E. to fulfill his father's vow to build a temple in honor of Yakushi Nyorai, the Buddha of Healing. One of the oldest extant copies of the *Heart Sutra*, likely dating to the eighth century C.E., was written on palm leaf in Siddham script and is preserved at this temple.[41]

Iwasaki dedicated eight years to the devotional practice of painting pagodas with the *Heart Sutra*, often constructing the pagodas using eleven, seventeen, or twenty-one rounds of the sutra.[42] This massive scroll is the culmination of the series, creating a pagoda with thirty rounds of the scripture, totaling 8,280 characters. In a remarkable feat of artistry and mathematical rigor, Iwasaki precisely calculated the size and placement of each character, thereby ensuring that the pagoda image and scriptural text would be complete with the same brushstroke.

The Buddhist path offers healing from the delusion of separateness, which causes loneliness, generates fear, and drives anger. To bring an end to suffering from such afflictions is the ultimate healing. Pilgrimage is one of many practices that people engage in to dissolve the poisons that imprison their hearts. On a journey to purify the heart-mind, the pilgrim in the foreground seeks wisdom in the presence of the Buddha of Healing enshrined in the pagoda. Architecturally, the path to enlightenment moves in circular fashion

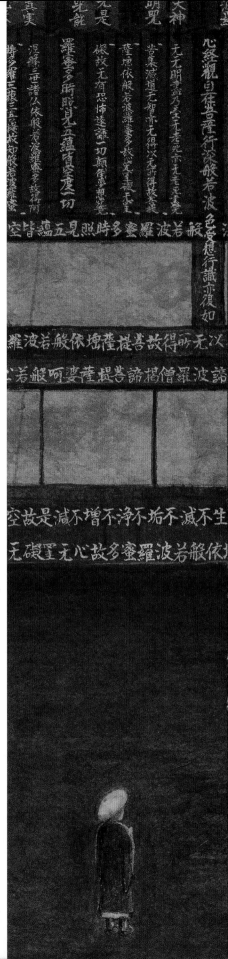

from the lowest level up to the highest levels of
attainment, delineated by the rings at the top. The
final goal of enlightenment is not featured in material
form. It is represented by the open expanse above the
top point, set against mountains that rise even higher,
a reminder of the infinite wisdom that is present
within, yet ever surpasses, the temples, images, and
scriptures that give it expression. Liberated from self-
limiting perceptions of reality, the pilgrim can heal
and go forth with compassion to alleviate suffering.

Pilgrimage to a Pagoda detail.

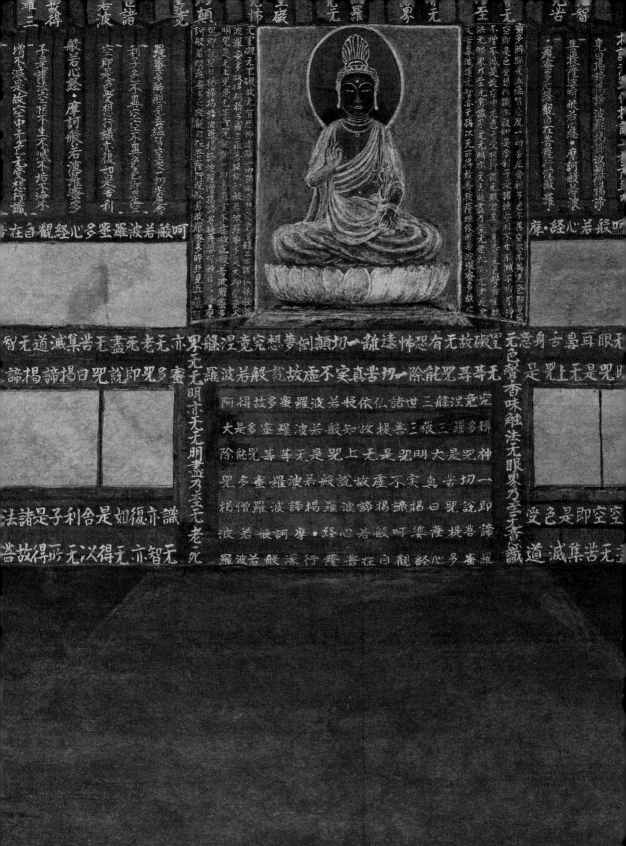

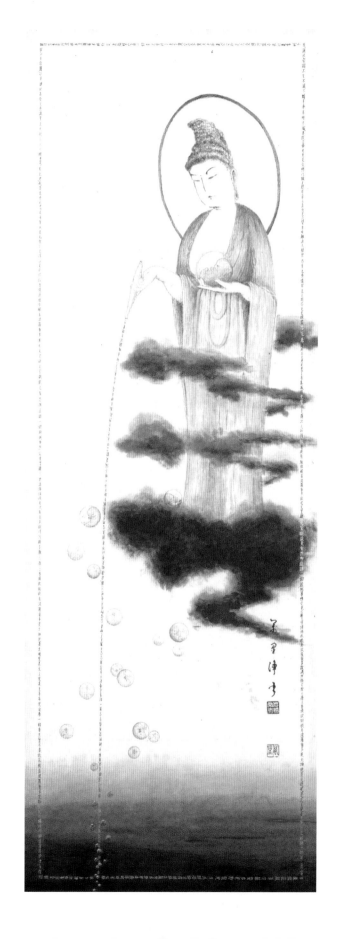

Forgiving

MIZUKO: WATER CHILD (120 x 35 cm, 1997)

Who was I before I was born?

The power of art to ameliorate heartrending relationships is palpable in *Mizuko: Water Child*, for Iwasaki bares the traces left in his heart from his experience along the Chichibu Kannon Pilgrimage route. For over seven hundred years, Kannon has heard the cries of countless people who have hallowed this path, paving it with tears flowing from the spectrum of human suffering. Known for aiding travelers, including those moving through the six realms of existence, Jizō Bodhisattva watches over the pilgrims' journey as they chant the *Heart Sutra* at each of the thirty-four Kannon temples.

Iwasaki recounted to me the moment when he rounded a curve in the lush Chichibu mountains and witnessed thousands of red-bibbed stone statues of Jizō. Though not part of the traditional pilgrimage, Purple Cloud Mountain Jizō Temple (*Shiunzan Jizō-ji*, 紫雲山地蔵寺) has become renowned for these Jizō. Though offered at temples all over Japan, people come from afar to this temple cradled in the mountainside for its *mizuko* ritual. *Mizuko* (水子, water child) is the colloquial Japanese word for unborn fetus, whether stillborn, miscarried, or aborted. People, mostly women, make donations for a Jizō statue in honor of a *mizuko*. With each offering of toys and candy, they care for their *mizuko* and thank Jizō for tenderly ushering the youngest of travelers. Iwasaki felt the piercing pain that gave rise to the outpouring of Jizō enshrined there. Moved by the poignancy of the grief shared in an environment of mutual respect and healing, he, too, offered a prayer of compassion for the children returning to the primordial waters to be reborn in auspicious circumstances.

When Iwasaki returned home from this pilgrimage, he found the *Heart Sutra* guided him to a deeper awareness of interbeing. Notice how the elixir of compassion does not flow *out* of Kannon's vase, as

it does in all other paintings with the goddess of compassion pouring her vase. In *Mizuko: Water Child*, the *Heart Sutra* streams back *in*, indicated by the characters being upside down and reading from bottom to top. Protected in womblike bubbles, *mizuko* rise into Kannon's vase and become her elixir of compassion. This provocative and visually compelling painting manifests a love that transcends birth and death, a compassion that knows no bounds.

The wisdom of *mizuko* rituals comes out of the context of embedding healing rituals into the cycle of birth and death. These rituals create a safe environment, as in a womb where nourishment is freely provided. Transporting us to that ritual space, where the heart-mind restores its suppleness, Iwasaki's painting soothes hearts rent by the loss of innocents and inoculates us against rigid thinking and harsh judgments. By offering a way to perceive the ebb and flow of birth and death, his painting inspires compassion and heals by making invisible connections visible.

OPPOSITE:
Mizuko: Water Child detail.

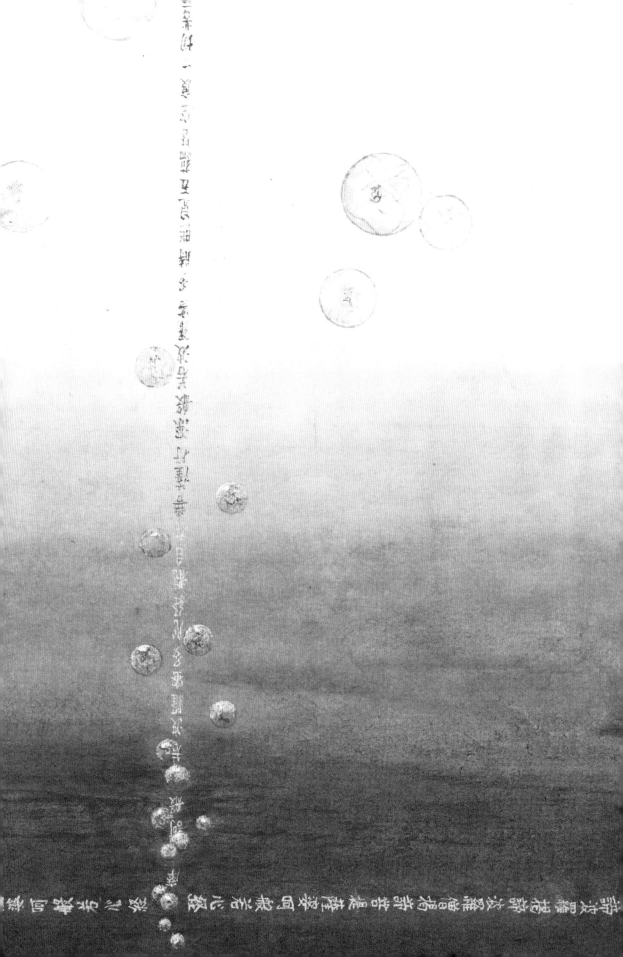

摩訶般若波羅蜜多心經

觀自在菩薩行深般若波羅蜜多時照見五蘊皆空度一切苦厄舍利子色不異空空不異色色即是空空即是色受想行識亦復如是舍利子是諸法空相不生不滅不垢不淨不增不減是故空中無色無受想行識無眼耳鼻舌身意無色聲香味觸法無眼界乃至無意識界無無明亦無無明盡乃至無老死亦無老死盡無苦集滅道無智亦無得以無所得故菩提薩埵依般若波羅蜜多故心無罣礙無罣礙故無有恐怖遠離顛倒夢想究竟涅槃三世諸佛依般若波羅蜜多故得阿耨多羅三藐三菩提故知般若波羅蜜多是大神咒是大明咒是無上咒是無等等咒能除一切苦真實不虛故說般若波羅蜜多咒即說咒曰揭諦揭諦波羅揭諦波羅僧揭諦菩提薩婆訶般若波羅蜜多心經

TRANSMIGRATION (24 x 24 cm, 1994)

What am I transforming into?

Iwasaki explained this painting as his response to the sight of an
adorable African child reduced to skin and bones, on the verge of dying
from starvation. The horror of such an experience was too painful
for Iwasaki to paint in his usual meticulous and realistic manner.
Rather than portray an image that pierced him with a piteous sense
of impermanence, he offers a cosmic perspective of the elements
that eternally circulate through the universe, becoming stars, stones,
and living beings. He finds the solace of wisdom in the *Heart Sutra*
teaching that "there is no birth; there is no death," expanding his
perspective to the cosmic circumvolving of sky, earth, and spirit. This
abstract vision intimating a hollow skull is his prayer for compassion
for suffering children who die due to conditions beyond their control:
climatic disasters, political travesties, and global economic avarice.

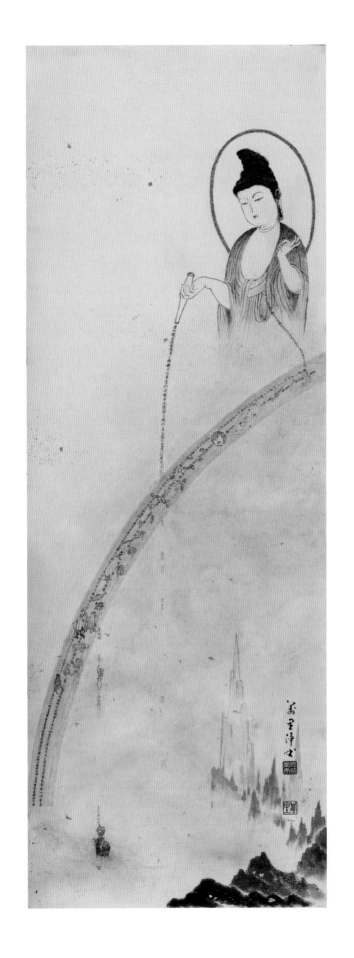

RAINBOW OF FORGIVENESS

(120 x 35 cm)

What can I do if I forgive?

It was not until after retiring from research on viruses that Iwasaki
saw he had divided reality up by looking at it only through his
scientific perspective. He felt mortified that he had not treated with
respect the animals that supported his research, only seeing them
as things to measure. He looked mournful as he explained how this
painting was his expression of repentance from his estranged way of
relating to his animal research subjects. He wanted to focus on reality
in its wholeness. Contemplating nonduality—that ultimately there is
no subject and object—released guilt and shame that constricted him.
As his heart became unbound, penetrating gratitude flowed to the
animals that had helped him, especially silkworms. Gratitude helped
him see reality in its wholeness, and forgiveness helped him return to
wholeness.

Squarely facing this reality, he paints himself in hell to assist the
animals out of the realm of suffering to which he had conscripted
them. With an exultant awareness that research animals are integral
to the greater whole, he entrusts the beauty of a rainbow to convey
his gratitude and to celebrate opening his heart to our wholeness.
Effulgent with *Heart Sutra* wisdom on the interrelated nature of
existence, Iwasaki's *Rainbow of Forgiveness* accentuates forgiveness
as an act of compassion to the self, which activates compassion for
others.

Rainbow of Forgiveness detail.

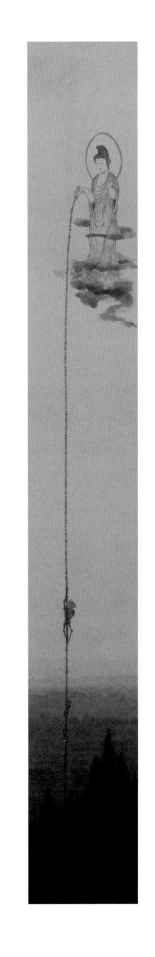

CLIMBING OUT OF HELL <small>(120 x 18 cm)</small>

What hell have I made for myself?

> Greed is strong.
> Hate is strong.
> Delusion is strong.
> Wisdom is stronger.

Kannon, the goddess of compassion, pours nectar into hell to relieve suffering beings. Her elixir is a stream of *Heart Sutra* wisdom that offers a means of ascent for the skeletons climbing the luminous strands. Iwasaki references a popular Japanese novel by Akutagawa Ryunosuke, *Kumo no Ito* (*The Spider's Thread*), in which so many people simultaneously attempt to climb out of hell on a spider's thread that the web breaks from the weight of their greed. The artist casts wisdom as a power that can lift beings from hells of their own making.

Having served in the army in World War II, Iwasaki has a visceral insight into the depths of suffering to which humans can descend. Indeed, in a stunning effort to accurately paint the angles of the bones of the skeletons, he served as his own model. At age seventy-five, he suspended a rope from a tree branch in his garden and videotaped himself climbing up and hanging on to the rope. He thereby painted himself among those in hell. The meticulous precision with which he renders the bones expresses an intimate care and tender respect for beings in hell. It also evokes the surgical skill required to remove afflictions that provoke suffering.

We constantly do things in order to not suffer. We shield our eyes from bright sunlight. We repel repugnant odors and dismiss disgusting people. We pursue that which we think will quell our loneliness or quench our desires. Yet not all efforts are effective. We land ourselves in various hell realms by seeing permanence in the

impermanent, pleasure in that which causes pain, and foes in those who are part of the same human family. Just as we can predict something will fall due to the force of gravity, we can predict suffering when actions derive from afflictive mind states such as fear, anger, jealousy, and greed. Mental afflictions distort perception. These misperceptions lead to miscalculated reactions. As pain indicates a need to tend to an ailment, suffering is feedback that one is not perceiving the interdependent whole. Suffering teaches us when our choices are not compassionate, for compassionate action is the antidote to suffering.

OPPOSITE:
Climbing Out of Hell detail.

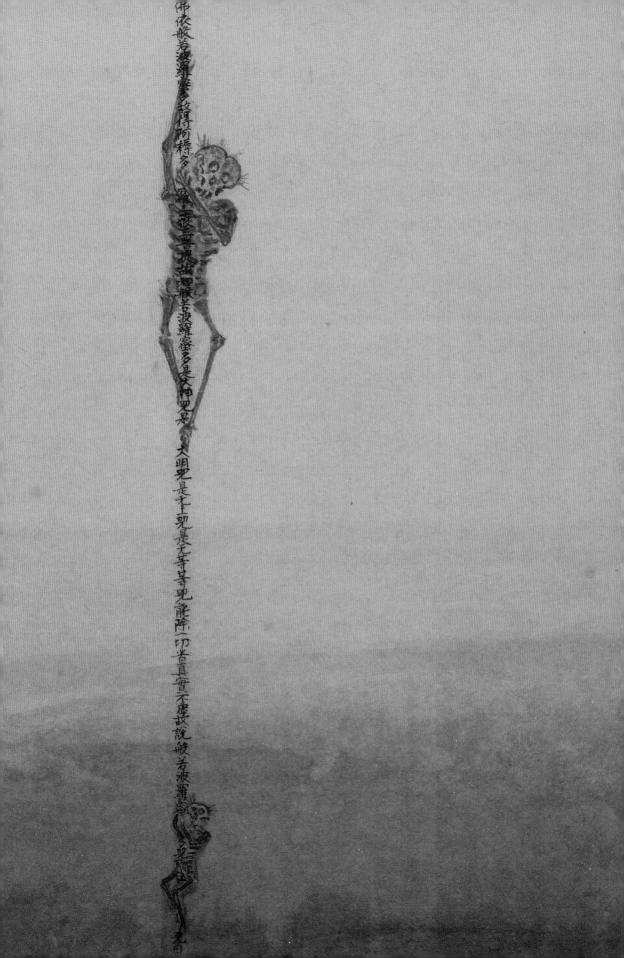

佛依般若波羅蜜多故得阿耨多羅三藐三菩提故知般若波羅蜜多是大神咒是大明咒是無上咒是無等等咒能除一切苦真實不虛故說般若波羅蜜多咒即說咒曰

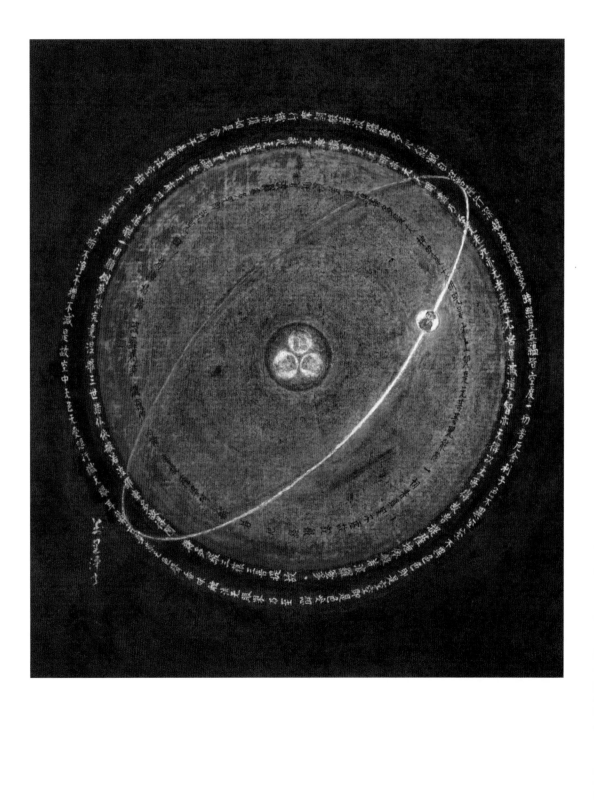

ATOM (27 x 24 cm)

What is life made of?

Hydrogen makes up 75 percent of the atoms in the universe. It is pervasive on Earth, giving water and life to all beings. Drawing on the representation of the atom developed by Niels Bohr, one of the fathers of quantum physics, Iwasaki paints a hydrogen atom with the *Heart Sutra*. Its electron is a Buddha swirling around rings of the scripture. In a nod to quantum mechanics, he delineates three quarks inside the proton at the center of the atom. Quarks are subatomic particles so small we will never see them, but we are reliant on their strength to navigate the material world, from sitting on chairs to climbing mountains. Iwasaki makes the quarks out of Buddhas. Buddha is a trope for the activity of nondual wisdom or "form is emptiness; emptiness is form." In making quarks Buddhas, Iwasaki is showing us that all forms are enlightened Buddhas and that it is Buddhas "all the way down."

Another reading of *Atom* to elicit the sutra's wisdom is to see the atom in the form of the hydrogen isotope tritium. Although its electron is still a Buddha swirling around rings of the *Heart Sutra*, the nucleus of this radioactive isotope is interpreted differently. One proton and two neutrons constitute tritium's nucleus. A Buddha fills each of these three particles. The tritium atom powers suns and stars in a process of fusion whose cosmic rays interact with Earth's atmosphere, though leaves only traces. Iwasaki's choice to convey the *Heart Sutra* using this atom urges us to see that the Earth is part of a dynamic cosmos. Humans have harvested and manipulated this atom's potential in service, among other things, of constructing bombs. First came uranium, enabling President Harry S. Truman to exclaim on August 6, 1945, "It is an atomic bomb. It is a harnessing of the basic power of the universe." A plutonium bomb devastated Nagasaki three days later.

Scientists would soon supersede these weapons of mass destruction by unlocking the power of fusion to create a hydrogen bomb with more than five hundred times the power of those unleashed on Japan. As a survivor of World War II, Iwasaki manifests the expansive compassion of the *Heart Sutra* in his Buddha-filled hydrogen atom.

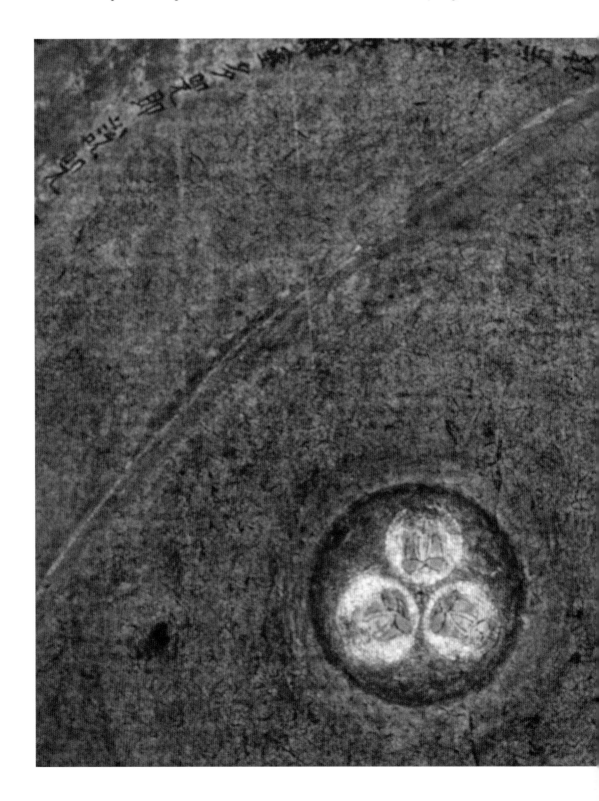

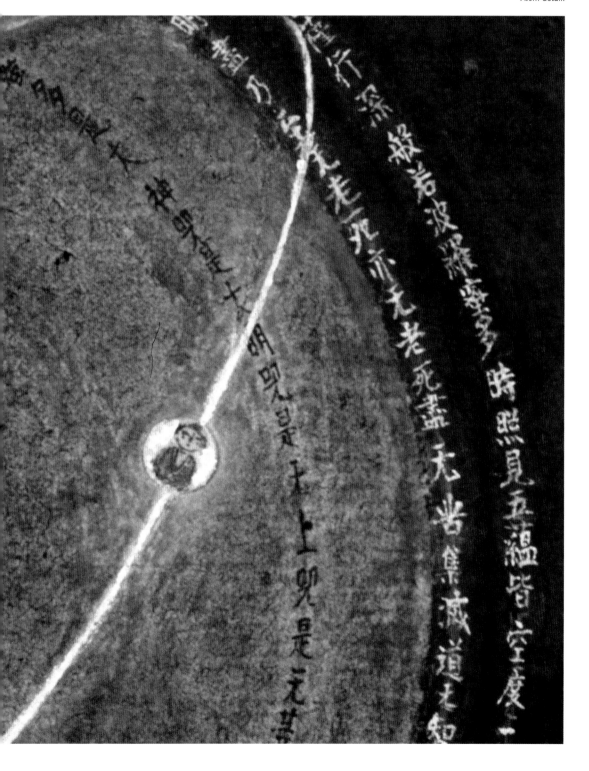

ECLIPSE (140 x 74 cm, painted July 25, 1995)

What obstructs my view?

Wreathed in flames of wisdom, Fudō Myō-ō is a manifestation of the Sun Buddha (Skt. *Mahavairocana*; Jap. 大日如来 *Dainichi Nyorai*). Iwasaki paints this agent of compassion blazing in immense whirling convolutions of solar storm activity called solar prominences. Solar prominences are electrically charged hydrogen and helium atoms spewing out of sunspots along the magnetic field lines of the sun. Their temperatures soar to around 6,000 kelvin, and their heights reach hundreds of thousands of kilometers. Fudō's wrathful visage, accentuated by one fang pointing up and another pointing down, piercingly glares at planet Earth and its moon. Gazing from the vantage point of Earth, the moon appears large. From the perspective of the sun, however, the moon is miniscule. Yet the meager moon has totally eclipsed the enormous sun from Earth's view!

Likewise, the slightest dualistic thought can obscure one's view of the vast nondualistic activity of the universe. When viewed from their inherently narrow and rigid perspective, dualistic thoughts appear to loom large. Dominating our view, they prevent us from seeing beyond. Appearing big and solid, they block out the ever-changing interdependent flux of reality. But when you expand your perspective, you can see they are paltry and weak compared to the vast power of transcendent wisdom and compassion. Just as the moon's night glow is no match for the sun's power to dispel darkness, ignorance is no match for wisdom.

Like the nuclear fusion that generates the sun's radiant warmth, Fudō's compassionate activity is fueled by the intensity of nondual wisdom's obfuscation-busting force: emptiness. Emptiness is a potent dissolving agent that removes even stubborn obstructions to nondual wisdom. Utterly precise, emptiness does not harm anything that does

not hamper. A cosmic solar prominence of writhing superheated electrified gas, expert marksman Fudō wields his compassionate lasso of emptiness. He unfurls it to fetter all obscurations of the vast interdependent activity of the cosmos, his eyes now set on lassoing the moon.[43]

From birth on, obstacles accumulate with each experience that generates a belief in a separate self, a tormenting and tenacious dualistic thought. Isolation is felt with each pang of hunger and every ache from bumps and falls. When we release tears and shrieks in an effort to be heard, understood, and loved, and our cries are not met with conciliating comfort, the sense of being exiled and unworthy is amplified. When the cumulative feeling of desolation grows so strong that we despair of ever being loved or treated with kindness, violent actions might erupt in a desperate attempt to reach out and connect to others. In extreme maladaptive ways, rage, terror, killing, and rape are ways to make direct contact with others. Addictive behavior is also a flawed attempt to satiate the longing to belong, to feel love. Healing from abuse, addiction, and violence requires a fiercely focused force to burn off false beliefs of being unlovable, delusions of isolation, and fear of abandonment. Once these obscurations are removed, one can see that one is not really broken nor separate from the whole. Freed from false perceptions, you, too, can release the tremendous power generated when delusions are burned away; you can ignite flames of compassion to consume poisons and cremate suffering.

Iwasaki's veracious and voracious image of a total solar eclipse and a solar prominence erupting beyond the sun's chromosphere depicts the *Heart Sutra* as celestial power. It flames incandescent wisdom and brandishes compassion to thwart ignorance and purify delusions, to transmute anger into luminous wisdom and incinerate all obstacles to enlightenment.

OPPOSITE:
Eclipse detail.

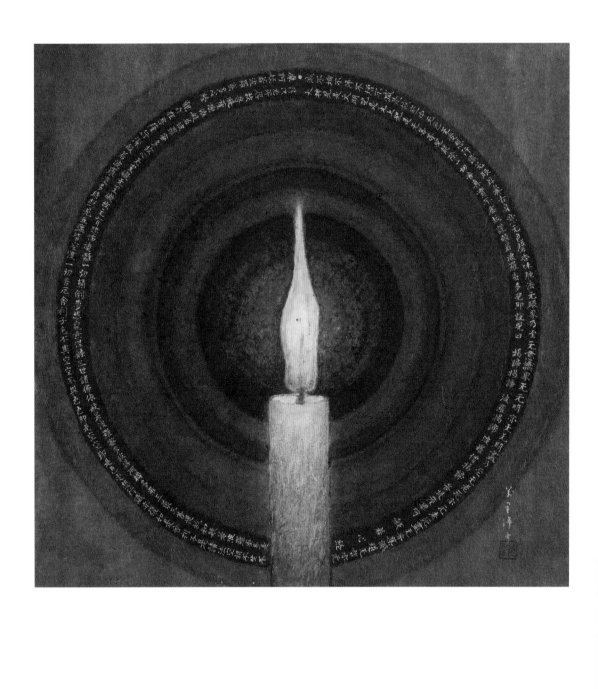

CANDLE LIGHT (27 x 25 cm, 1992)

What do I illuminate?

A simple candle flame enhaloed with sacred words bears witness to the wisdom of our hominid forebears, who discovered the power of fire. For thinly furred mammals exposed to the cold elements of winter, fire was key to their survival. They discovered that dancing flames freely offer their life force from stick to stick, growing stronger when shared. Flames transform whatever they touch, warming what is cold and lighting what is dark. Like a heartbeat, flames pulse with life.

It is no wonder, then, that making an offering of light in the form of a glowing flame is a common religious gesture of reverence and desire for illumination. As a scientist, Iwasaki understands that light is energy that fuels the universe and that what humans perceive as darkness is simply differing degrees of light. Light waves and photons pervade the universe. Illumination is ever present. Wisdom can be found everywhere. The flame of this candle is the radiant wisdom of the *Heart Sutra*, dispelling delusion, enlightening the universe.

HEALING INCENSE (94 x 16 cm, 1993)

How would it feel to let my fear dissolve into thin air?

A stream of incense mist ascends, settling upon a calmed heart.
— RENNYŌ SHŌNIN (1455–1499)
Restorer of the True Pure Land Sect of Japanese Buddhism

As it was for Iwasaki, the devotional act of offering incense at a home altar is a daily practice for countless Buddhists. In the privacy of home, people can feel safe enough to be vulnerable and listen to the murmurings of their hearts. Whether the innermost voice emerges as moans of mourning, keenings of anger, whimpers of fear, songs of joy, canticles of relief, or lyrical gratitude, the incense wafts into the interstices of the heart, caressing tender places with a healing aroma. Indeed, as a sacred act, Iwasaki lit incense while painting, infusing each brushstroke with the fragrance of compassion.

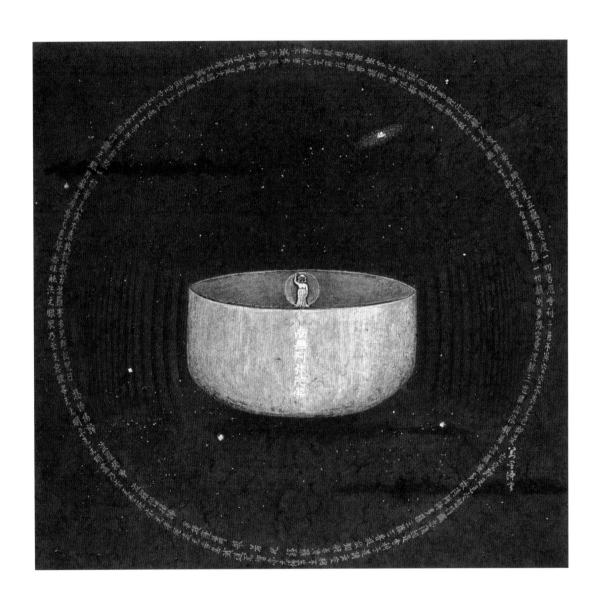

RINGING BELL (39 x 37 cm)

How do I make my heart ring with compassion?

Summoning the bodhisattva of compassion, Kannon—whose name in Japanese means "see sound"—Iwasaki shows us sound waves resounding into the cosmos, echoing the spiraling galaxy. Signified by *ensō* circles, the waves ripple with the teachings of the *Heart Sutra*.[44] The baby Buddha brims with the timbre of growth. Carved in gold, "Namu Amida Butsu" heralds the vow of compassion embedded in each toning of the bell.

After his mother passed away, Iwasaki continued her morning ritual of lighting a candle, offering incense, and ringing the home altar bell before chanting. Tolling a bell in your home bathes the inhabitants in currents of calming compassion and suffuses the home with the sound of wisdom. Listening to a bell with our heart creates a space safe for dissolving debris, unclogging lines of connection, and dispelling clouds that obscure our vision. Subtle and nimble, the sound waves infuse each sliver and crack in the heart with the healing that comes from being made whole with the fullness of the present moment. Here, world peace does not sound naïve. The voice of justice does not ring hollow. Ritually intoning a bell enables us to hear the complex harmonies of the cosmos as one moves through one's day attuned to the *Heart Sutra*.

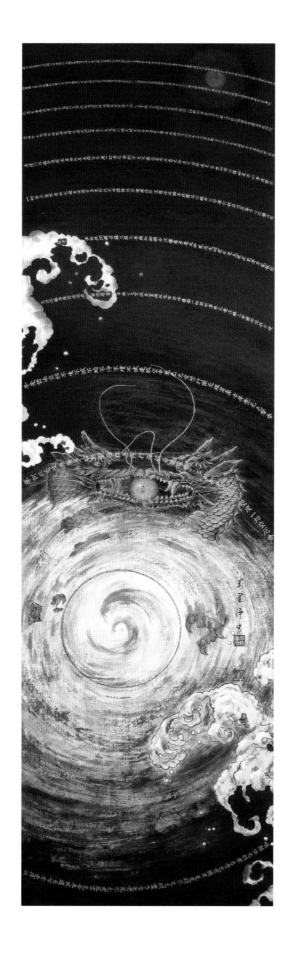

RADIATING PEARL (144 x 45 cm)

Can I hear the heartbeat of the cosmos?

Iwasaki shared with me that his inspiration for this painting occurred at an all-night vigil for a relative who passed away. He was striking the wooden drum (*mokugyō*) as he chanted by the altar when he noticed the dragons carved into the handle were holding a pearl, the jewel of enlightenment. Heartened, he created this painting of sound waves resounding from a dramatic dragon drum for keeping people on beat with the rhythm of the cosmos. He explains, "I covered the part of the *mokugyō* you hit with a whirlpool of clouds. The sound of the *mokugyō* resounds from the *hara* [source of power in lower abdomen] of the dragon, releasing the sound of the Buddha's compassion into the universe, reverberating and liberating life."[45]

The painting evokes the sound of the *Heart Sutra* chanted. Chanting is the way most people experience the *Heart Sutra*. The body resonates with the sound waves, evoking an experience of the nondual wisdom the sutra teaches: emptiness, interbeing, impermanence, and the fullness of here and now. Intoning the sutra in the body connects one to all things as the sound reverberates through oneself and out into the cosmos, leaving no material traces. Synchronizing the beat of the chant and the heart, we can feel the pulse of liberating wisdom course through our bodies.

> Thumping the dragon's belly
> To the beat of the heart,
> The sound of compassion
> Resounds through all forms.
>
> The pearl of liberation
> Radiates in all directions.

般若心経

STARRY SKY (44 x 43 cm)

What if I saw my whole life in a single moment?

Stars' nuclear reactions illuminate the night sky, enabling us to know where we are in spacetime. A steady gaze reveals we are in perpetual motion and not alone in this vast expanse. We are an integral part of a dynamic cosmos. Viewing stars swirling in the sky above is also an enigmatic form of time travel. We can see millions of years into the past while standing still in the present moment, expanding notions of here and now.

Tōji Temple's pagoda dominates the southern landscape of Iwasaki's hometown, the ancient capital of Kyoto. Looking toward the pagoda in the night sky, the stars appear to properly circumambulate the pagoda clockwise, as if they, too, are joining in this time-honored practice for cultivating enlightenment.

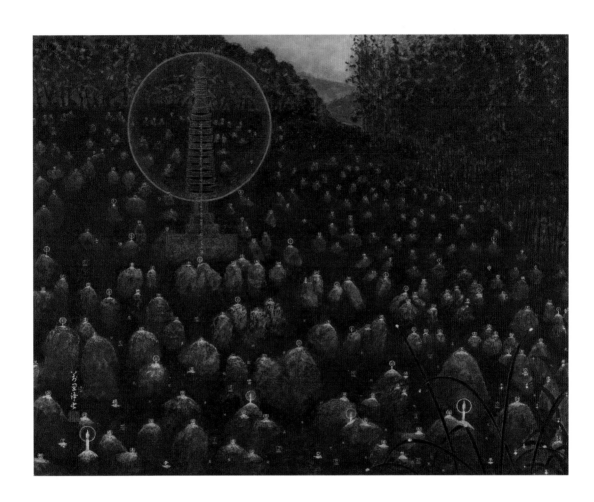

ADASHINO: GRAVEYARD OF STONE BUDDHAS (75 x 60 cm)

How does death nourish life?

留まるべさかはあだし野の葉ごとにすがる白露
　　—西行

Indifferent to longevity, glistening dewdrops embrace
each blade of grass on the field of Adashino.
　　—SAIGYŌ

During the late nineteenth century, local members of a Pure Land
temple cradled by mountain trees on the outskirts of Kyoto gathered
abandoned gravestones from previous centuries and arranged them
around a stone-carved stupa on the temple grounds. Adashino
Nembutsu Temple (あだし野念仏寺) holds a memorial service for these
neglected Buddhas each year on August 23 and 24. Candles are offered
to each of the one thousand stones of the "Buddhas without Kin"
(*Mu-en Botoke*, 無縁仏). The character for *Adashi*, 化, evokes a quiet
aching over evanescence and ushers one to awareness of the cyclical
transformation of life and death. Iwasaki related to me how, after he
paid his respects, he returned home and painted hundreds of intricate
skeletons. As he burned incense and chanted the *Heart Sutra*, he
buried the beings who have crossed to the other shore with *sumi* ink.
After painting each stone, he filled his heart with compassion for each
Buddha and lit candles with the flame of wisdom that shines through
the characters of the *Heart Sutra*. Evanescent dewdrops sparkle on
the grasses in the foreground, intimating the glistening beauty of
ephemerality.

Birth is not the beginning of suffering, and death is not its end.
Neither does the cessation of suffering mean you will not die. Death is
not an optional experience, nor is it a personal failure. Birth and death

show us the nature of emptiness. When viewed nearby, it looks as if there is birth and death. However, when viewed from the plenitude of our boundlessness, there is no birth and death. When you examine the morphology of transformation, you see that skeletons fertilize soil and soil grows edibles that sustain animals. In a fundamental way, death unleashes our capacity to nourish each other. Death makes possible the most profound kind of connection; to see it this way is to touch the intimacy for which we so often ache. Indeed, to see the beauty of death is to see how emptiness is a wellspring of compassion.

Iwasaki's painting transports us to a ritual that offers a close-up view of death in all its fullness. Mortuary rituals are embedded with the wisdom that grief has seasons as sure as winter follows autumn and summer follows spring. Ushering us through the seasons, rituals prompt us to see ephemeral beauty and experience the healing balm of emptiness: suffering passes, anger melts, jealousy dissolves, and fear is left with nothing to fear. Emptiness is the condition that ensures we will never be alone.

あだし野の露きゆるときなく
Adashino field dew never vanishes.
—TSUREZUREGUSA

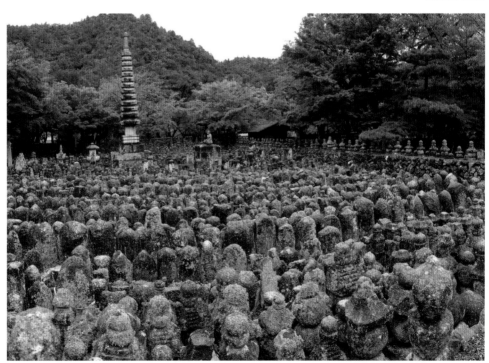

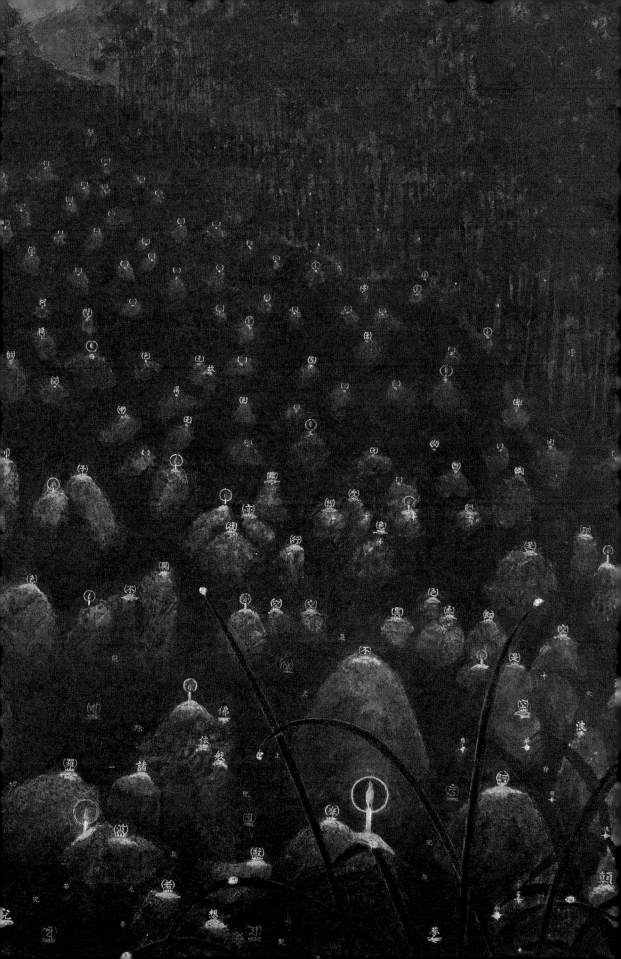

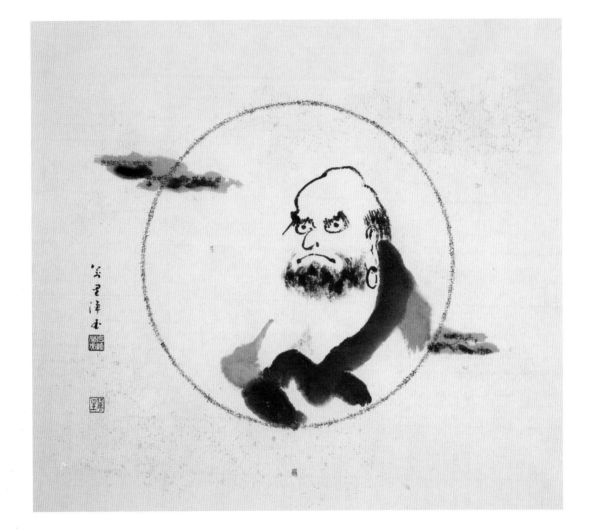

BODHIDHARMA <small>(53 x 45 cm)</small>

Which direction is my path going?

Recognized as the founder of Zen Buddhism, Bodhidharma is said
to have traveled west to China in the fifth century. People still ponder
the koan: "Why did Bodhidharma come from the West?" Depicting
the Zen master in accord with tradition—intense visage, bulbous eyes,
bushy eyebrows, full beard, and elongated ear adorned with a ring—
Iwasaki haloed Bodhidharma with an *ensō* circle of the *Heart Sutra*
to signify he is enlightened. Bodhidharma is heralded for practicing
seated meditation in a cave for nine years in order to stop suffering.
His legendary effort made him a paragon of awakened intent,
concentration, and mindfulness. He demonstrated how disciplining
the body-mind frees one from obstructions and mental afflictions,
enabling one to experience emptiness. Willingness is the key. Here is
a nugget of wisdom his enlightened perspective yielded. When you do
not act from a compassionate heart, you suffer. It is a choice. Be on the
path of suffering or the path of compassion.

DO ANTS HAVE BUDDHA-NATURE? (50 x 37 cm)

Who supports my journey?

In reference to *Do Ants Have Buddha-Nature?*, Iwasaki chuckled as he told me how he had transposed a famous Zen koan—"Do dogs have Buddha-Nature?"—to make a delicious pun on the Japanese words *have* (有り, *ari*) and *ant* (蟻, *ari*). Understanding the implications of "have" is the key to cracking the riddle, for the nature of dogs, ants, and even Buddhas is a fluid and dynamic process, not an object that one might have. In this painting, the words of the *Heart Sutra*, in black ink on a tawny earthen ground, are ingeniously contorted into the shape of ants meandering across the horizon. By not showing a beginning or end to the procession, Iwasaki intimates the path is the journey. Iwasaki fed the ants in his garden so he could observe their behavior. A small cluster of ants carries a Buddha, while others carry religious epigrams. This humorous personification interposes humans and insects in a way that challenges human hegemony and elevates minute arthropods.

Ants are exemplars of cooperative living. Although in isolated numbers they act independently, once they reach a critical mass, they begin to behave as one organism. They organize according to distinct functions and coordinate in ways that support the group. One might call cooperating for the good of the whole community "antropy." Human ways driven by notions of "us" and "them" are manifestly maladaptive. Greedy and delusive decisions to spew toxins into the fundamental elements of air, water, and earth threaten our survival. Perhaps humans will also reach "antropy" and begin to move as one organism that acts to sustain the whole.

To the scientific verity that life on Earth would end with the disappearance of ants, Buddhism brings the perspective that ants

and all sentient beings traverse a multilife journey
toward enlightenment. The spiritual life of ants in
ceremonial procession highlights their wisdom and
underscores the sanctity, and ultimate importance,
of the seemingly inconsequential creatures crucial to
our shared reality.

Do Ants Have Buddha-Nature? detail.

MOONBEAM (105 x 17 cm, 1987)

How do I limit my view of reality?

Moonbeam directs us to the advice "not to mistake the finger pointing to the moon for the moon." This is usually interpreted as a poetic way to caution against focusing too closely on the "finger"—words, teachings, language, or any object—and not see the "moon," a ubiquitous metaphor of enlightenment. Iwasaki's *Heart Sutra* moonbeam shines wisdom and compassion on all in its path. A contemplative figure points a finger to the moon at the same time the moonbeam points to the finger, conveying there is no subject or object. It is one event. It is "not two." This is wisdom. Even when one mistakes the finger pointing to the moon for the moon, the moon still shines. This is compassion.

CAT'S EYE: BUDDHA'S MIRROR

(75 x 66 cm, February 14, 1995)

What does the eye of wisdom see?

Iwasaki's eyes twinkled as he told me he was moved to paint *Cat's Eye: Buddha's Mirror* by seeing himself reflected in the eyes of a stray mother cat he had been feeding. The distinction between himself and the cat dissolved. He realized the seer is the seen. Ultimately there is no separation—no "me" and "you," no "us" and "them." When one can see reality as it is when looking at anything—undistorted by anger, greed, delusion, fear, or insecurity—one sees with a depth that reaches all the way through to oneself. This view of the interdependent nature of our being brings into focus the nondual quality of reality and the exigency of compassion.

To illustrate this insight, Iwasaki embedded an eye with the Sanskrit seed syllables of the "Five Wisdom Buddha" mandala. The symbolism enlivens the enlightenment practices of transmuting five types of negativity into five aspects of wisdom. Delusions transmute into a wisdom that offers an unobstructed view of reality. Greed transmutes into the wisdom of generosity. Selfish desire transmutes into the wisdom of compassion. Jealousy and insecurity transmute into all-accomplishing wisdom, enabling one to act in ways that effectively cease suffering. Anger transmutes into mirrorlike wisdom, reflecting everything clearly and accurately.

This philosophically, ontologically, and existentially profound painting emerges from a tender concern to care for a particular hungry and vulnerable being. With an unobstructed view of reality, it is clear that compassion is not an abstract ideal suitable only for transcendent beings. Compassion occurs in concrete acts, done in specific places, in the present moment. Look into this mirror and you, too, will see

yourself: an interdependent being capable of transformative wisdom and restorative compassion, a Buddha.

Cat's Eye detail.

般若波羅蜜多心經

觀自在菩薩行深般若波羅蜜多時照見五蘊皆空度一切苦厄舍利子色不異空空不異色色即是空空即是色受想行識亦復如是舍利子是諸法空相不生不滅不垢不淨不增不減是故空中無色無受想行識無眼耳鼻舌身意無色聲香味觸法無眼界乃至無意識界無無明亦無無明盡乃至無老死亦無老死盡無苦集滅道無智亦無得以無所得故菩提薩埵依般若波羅蜜多故心無罣礙無罣礙故無有恐怖遠離一切顛倒夢想究竟涅槃三世諸佛依般若波羅蜜多故得阿耨多羅三藐三菩提故知般若波羅蜜多是大神咒是大明咒是無上咒是無等等咒能除一切苦真實不虛故說般若波羅蜜多咒即說咒曰揭諦揭諦波羅揭諦波羅僧揭諦菩提薩婆訶

般若波羅蜜多心經·摩訶

般若波羅蜜多心經

觀自在菩薩行深般若波羅蜜多時照見五蘊皆空度一切苦厄舍利子色不異空空不異色色即是空空即是色受想行識亦復如是舍利子是諸法空相不生不滅不垢不淨不增不減是故空中無色無受想行識無眼耳鼻舌身意無色聲香味觸法無眼界乃至無意識界無無明亦無無明盡乃至無老死亦無老死盡無苦集滅道無智亦無得以無所得故菩提薩埵依般若波羅蜜多故心無罣礙無罣礙故無有恐怖遠離一切顛倒夢想究竟涅槃三世諸佛依般若波羅蜜多故得阿耨多羅三藐三菩提故知般若波羅蜜多是大神咒是大明咒是無上咒是無等等咒能除一切苦真實不虛故說般若波羅蜜多咒即說咒曰揭諦揭諦波羅揭諦波羅僧揭諦菩提薩婆訶

般若波羅蜜多心經·摩訶

般若波羅蜜多心經

觀自在菩薩行深般若波羅蜜多時照見五蘊皆空度一切苦厄舍利子色不異空空不異色色即是空空即是色受想行識亦復如是舍利子是諸法空相不生不滅不垢不淨不增不減是故空中無色無受想行識無眼耳鼻舌身意無色聲香味觸法無眼界乃至無意識界無無明亦無無明盡乃至無老死亦無老死盡無苦集滅道無智亦無得以無所得故菩提薩埵依般若波羅蜜多故心無罣礙無罣礙故無有恐怖遠離一切顛倒夢想究竟涅槃三世諸佛依般若波羅蜜多故得阿耨多羅三藐三菩提故知般若波羅蜜多是大神咒是大明咒是無上咒是無等等咒能除一切苦真實不虛故說般若波羅蜜多咒即說咒曰揭諦揭諦波羅揭諦波羅僧揭諦菩提薩婆訶

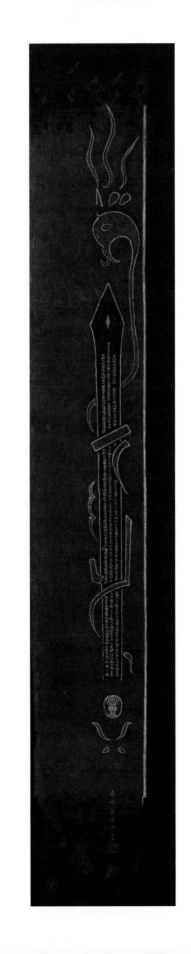

SWORD OF WISDOM (88 x 16 cm)

How can I cut through what binds me?

> With the discerning wisdom of an enlightened being,
> With the skill and precision of a gifted surgeon,
> With the healing compassion of a devoted mother:
>> Sunder all aversions!
>> Sever all attachments!
>> Slice through delusions!
>> Rend all fear!
>> Cut off all that does not serve love and harmony!
>>> —ADVICE FROM FUDŌ'S "DRAGON SWORD OF WISDOM"

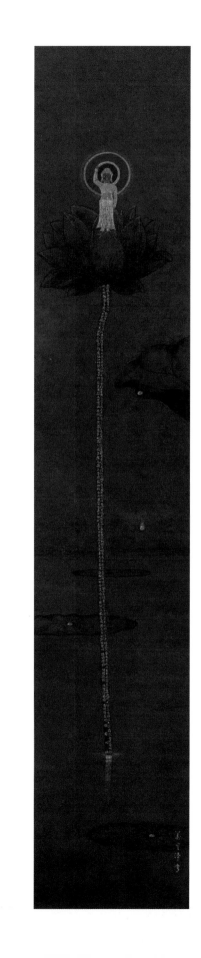

BLOSSOMING BUDDHA (96 x 21 cm)

What mud has helped me blossom?

A shimmering gold stem infused with *Heart Sutra* wisdom connects the mud and lotus blossom. These are the conditions in which a Buddha is born. Enlightenment blossoms in the mud. The more mud, the bigger the Buddha.

Wisdom into the nature of emptiness dissolves dichotomous thinking, including delineating distinct realms of samsara and nirvana. We transform when we change our perception, for reality is not a matter of true or false, good or bad, pretty or ugly. Reality is what it is. Likewise, form is emptiness and emptiness is form; samsara is nirvana and nirvana is samsara.

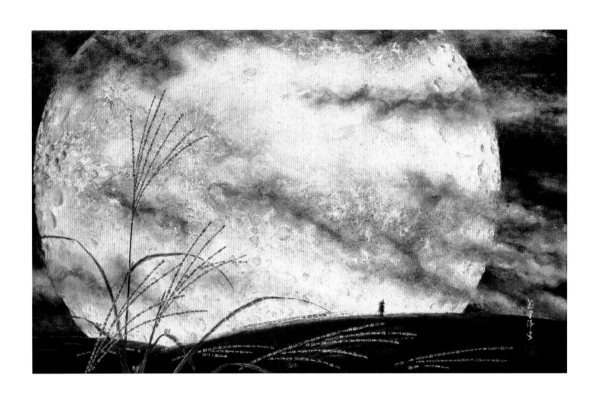

MOON VIEWING (100 x 60 cm)

How far do I have to go to see the full moon?

The moon casts
Rays of gold,
Awaking the night.

Seeker, do you hear
The homily ringing
Through the autumn air?

Bell-crickets peal:
The moon is always
Full.

Is a gentle breeze
Moving
The pampas grass?

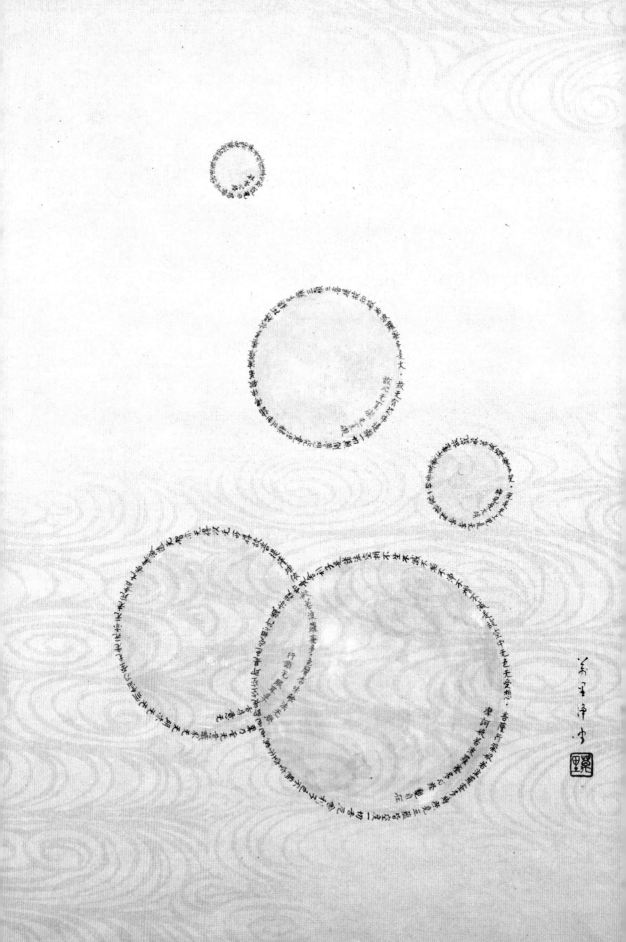

BUBBLES (37 x 25 cm)

How is impermanence fun?

Bubbles evokes the joy and wonder of children playing. Iridescent bubbles created with the *Heart Sutra* remind us to enjoy the beauty of the fleeting moment. Bubbles are conspicuously adept at liberating themselves from the illusion of being a solid, separate entity. If you listen carefully, you can hear bubbles pop, buoyantly bursting delusions. Would that we all played like bubbles!

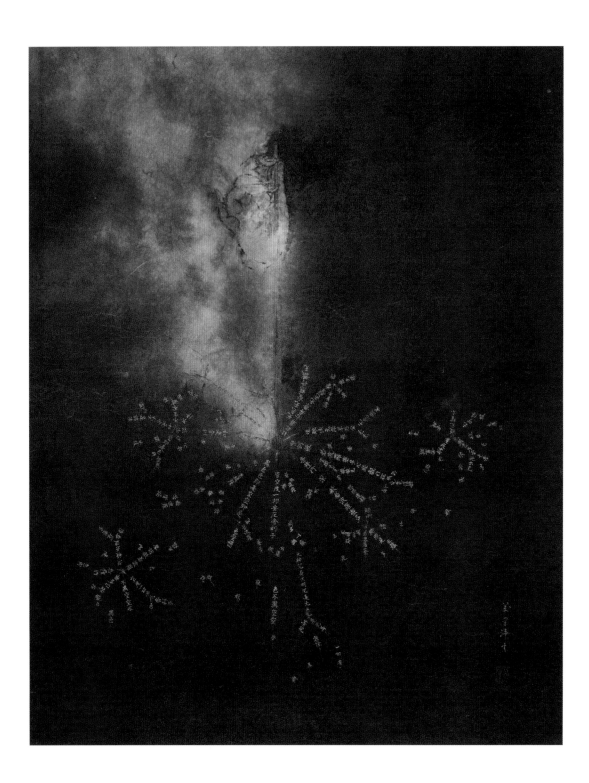

SPARKLER (40 x 31 cm)

Can I open my heart to the beauty that arises each moment?

A traditional Japanese sparkler twinkles like delicate embers of lace. It glitters and shimmers for a teasing wink of unalloyed delight, joyfully celebrating changing forms. [46]

Iwasaki's Zen teacher, Matsubara Taidō, likened his life to a sparkler. It helped him not feel scared of death during World War II.[47] He realized that defending himself with fear is what caused his suffering. Without fear obstructing our view of reality, we are freed to experience the beauty of impermanence.

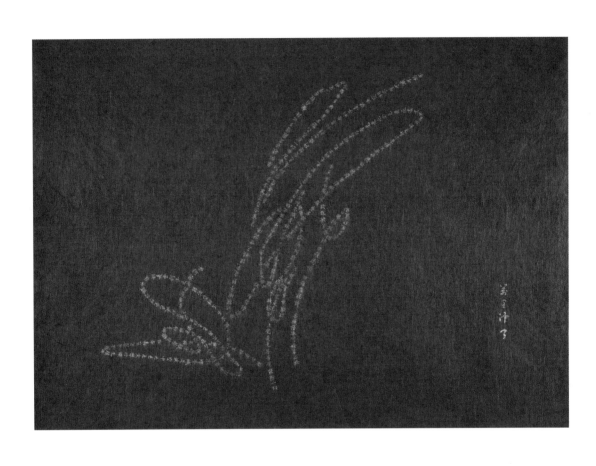

SCRIBBLING (41 x 32 cm)

What is my message?

Iwasaki imparted to me how a child inspired him to paint *Scribbling*.
In order to support children in a way that is helpful, we need to get to
know who they are. Iwasaki was notably concerned with what appeared
to be developmental delays in this child. One day the child—oblivious
of right or wrong, good or bad—manifested the fine motor skills to
express the lyrical lines of this first scribbling. Iwasaki paused to
reflect on his narrow concept of "normal" and "good." Awakened to the
wisdom of expanding his perspective, he ennobled the scribbling by
copying it with the *Heart Sutra*. He calls it "a message from Buddha."

SWIRLING EMPTINESS (27 x 22 cm)

What is in the sutra of my life?

Iwasaki was separated by fifteen centuries and a sea from
Hui-ching (578–650), a Chinese Buddhist who wrote the most
influential T'ang dynasty commentary on the *Heart Sutra*.
Yet Hui-ching's words sound like a description of Iwasaki's
painting.

> The purest emptiness has no image, but is the source of
> all images. The subtlest reasoning has no words but is the
> origin of all words. Thus, images come from no image, and
> words come from no word. These words that are no words
> arise in response to beings, and these images that are no
> image appear according to the mind. By means of words
> that are no words, bodhisattvas spread their teaching. And
> by means of images that are no image, buddhas appear
> in the world. This [*Heart*] sutra is thus the jewel of all
> teaching.[48]

Indeed, as testimony to the enduring and cross-cultural influence
of this brief text, Iwasaki's painting does arise out of a contemporary
Zen master's teachings on the *Heart Sutra*. Iwasaki shares the context
and inspiration for this painting.

> This painting gratefully arose out of a time when I felt
> relief from having completed painting hundreds of rounds
> of the *Heart Sutra*. I read Matsubara Taidō Sensei's book,
> *Introduction to the Heart Sutra*, which said, "The sutra that
> does not write words is superior to the sutra that writes
> words. People have forgotten the real sutra not written

in words. Shakyamuni explained it is vitally important to perceive all
phenomenal reality as a sutra."[49]

I woke up to the reality that the real sutra is in the midst of daily life.[50]

Iwasaki's most abstract painting reminds people of the fact that Shakyamuni did
not leave any writings of his teachings. He underscored that in order to stop suffering,
the teachings must be experienced in daily life. All sounds, smells, sights, tastes, and
sensations of phenomenal reality are the sutra without words, which leaves nothing
out. Iwasaki's wordless painting is his fullest expression of the *Heart Sutra* teachings.
It echoes layman Vimalakirti's roar of silence that has reverberated nondual wisdom
across the Buddhist world since the second century C.E. Expressing the activity
of emptiness with a swirl of subdued grays, blues, and blacks, Iwasaki highlights
the limitation of words—even those of a sutra on nondual wisdom—and the sutra
embedded in everyday activities.

Emptiness is just a word to indicate that which enables change and connection,
birth and death, growth and decay, suffering and bliss. Emptiness is the activity of
leaves growing, changing color, falling, and growing again. Emptiness is that which
enables us to feel hot in the summer and cold in the winter. It is that which enables us

to hear the morning song of birds, enjoy the smell of a flower, and feel the silkiness of a puppy's fur. It is that which powers us to take action in the face of abuse and violence and work with justice to diminish suffering. It is that which enables us to be aware of what causes suffering and what generates love, and what gives us the wisdom to know the difference.

Emptiness is a perspective that includes all without discrimination and judgment. Emptiness is what we can see through microscopes and telescopes, in caves, from mountaintops, and online via Google Earth. When we look from the perspective of emptiness, it is clear that we are all in this together. Therefore it is important to begin and end with emptiness when making decisions and choosing a course of action. Just as we will miss our mark if we don't take into account the force of gravity when calculating the trajectory of a rocket sent to the moon, we will miss our mark and generate suffering if we don't take into account the dynamics of emptiness when we try to love.

To experience emptiness is to experience no separation of subject and object, no winning or losing, no "us" and "them." In emptiness, there is no place to stand alone or stand your ground. When our point of reference is emptiness, no suffering ensues. When we experience emptiness, our actions manifest wisdom and radiate compassion.

Whether or not we are aware of emptiness, daily life is a streaming sutra expounding the liberating power of emptiness.

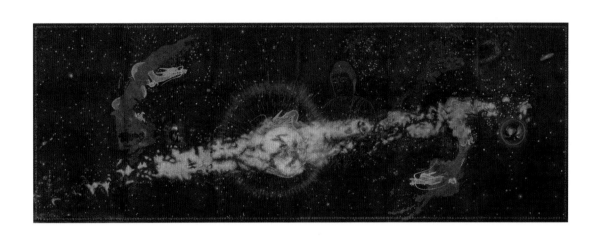

BIG BANG: E = MC² <small>(500 x 180 cm, March 2000)</small>

Where is home?

Iwasaki's magnum opus, *Big Bang: E = mc²*, illustrates the cosmic activity of transformation with the dynamic energy and forces at work in the *Heart Sutra*. Impermanence on a galactic scale shimmers across the seventeen-foot span that traverses six scrolls. The aesthetic rhythm of this painting is both thunderous and delicate as the eye dances across the cosmos and canticles through the galaxies. The darkness pulses with a vacuum of silence, scintillating with gold crescendos. Intricately rendering the 3,588 characters required to copy the *Heart Sutra* thirteen times—thirteen being a nondivisible whole number— Iwasaki draws the viewer into intimacy with an infinite vista.

Some 13.82 billion years ago, gravitational waves moving spacetime were generated by a burst of expansion called inflation. Stars were eventually born from elements that arose, fused, and transformed. Some stars exploded in supernova blasts that produced the gold in this painting. Due to various causes and conditions, there are a range of ever-in-flux stellar forms: red dwarfs, hypergiants, red giants, white dwarfs, neutron stars, pulsars, and black holes. Gravitational forces bring stellar forms together, begetting galaxies that make up less than 5 percent of our vast cosmos. The sea of black consists largely (68 percent) of dark energy, meaning we don't really know what it is.

Orienting the painting in a familiar region of the universe, we are shown the cosmos from our perspective on Earth. We are off on a spiraling arm of the galaxy, rather far from the black hole that churns at the center. Our Milky Way—whirling with over 400 billion stars and billions and billions of planets—is foregrounded, an expanse requiring 100,000 years at light speed (186,282 miles per second) to traverse. The tiny dots of gold and silver that orbit our galaxy are globular star clusters, living fossils from the dawn of our universe. Our nearest

LEFT:
Globular star cluster from dawn of our universe (*Big Bang: E = mc²* detail).

ABOVE:
Andromeda galaxy (*Big Bang: E = mc²* detail).

neighbor, the similarly spiraling Andromeda galaxy, is in the upper right corner in a swirling round of *Heart Sutra* energy. Due to the vast distance between us, however, we can only see Andromeda as it looked 200 million years ago. Delighting in images captured by the Hubble Space Telescope that revealed billions of galaxies, Iwasaki brushes small orbs containing a single character of the *Heart Sutra* to portend a galaxy.

Like a massive constellation for radiating the light of compassion throughout interstellar space, Iwasaki infuses the cosmos with a gossamer Buddha of Infinite Light, Amida. By summoning this luminous Buddha, Iwasaki invokes the power of wisdom and compassion available in our cosmos. He avouches our cosmos is a Pure Land, a womb that embraces with compassion and nourishes with wisdom.

Amplifying its numinous nature, Iwasaki enhances the universe with golden dragons, revered as powerful protectors of seekers of enlightenment. Dragons wield adamantine wisdom, surging through space with the energy of emptiness, the source of all forms. They transfer energy around the cosmos as they stir up interstellar debris and dust rich with elements that, in turn, give birth to new stars. The mother dragon on the right is incubating six star eggs in the North American Nebula. The dragon on the left protects the eight star eggs in the Eagle Nebula that features the "Pillars of Creation," the tallest pillar stretching four light-years high. The universe is an expansive womb where out of emptiness stars are birthed, die, and are reborn in an interdependent flux of cosmic energy.

ABOVE:
Five galaxies in deep space (*Big Bang: E = mc²* detail).

OPPOSITE:
Amida Buddha (*Big Bang: E = mc²* detail).

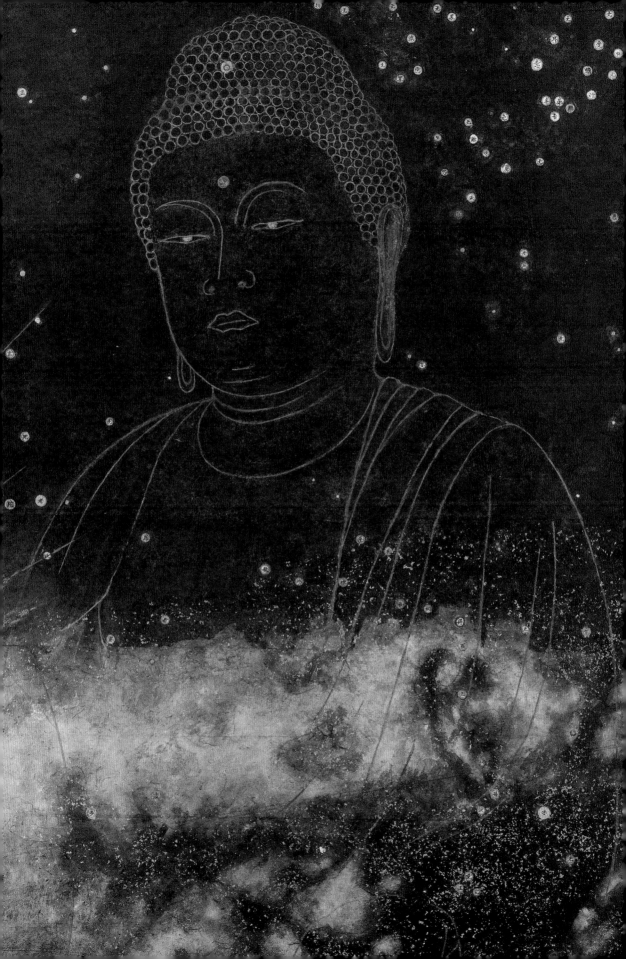

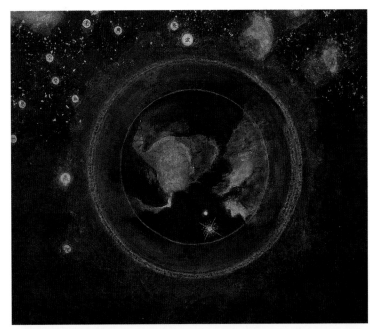

LEFT:
North American Nebula with six star eggs (*Big Bang: E = mc²* detail).

BELOW:
Dragon and "Pillars of Creation" Eagle Nebula with eight star eggs (*Big Bang: E = mc²* detail).

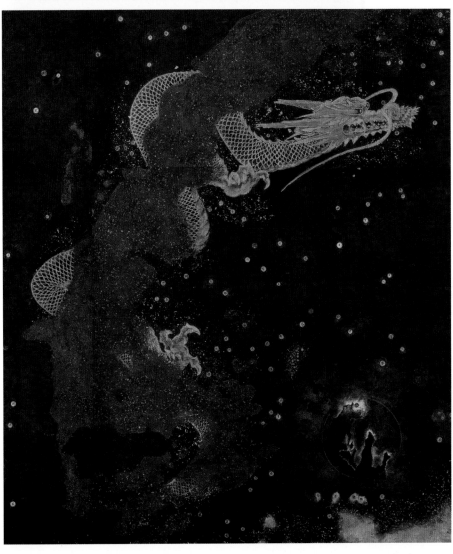

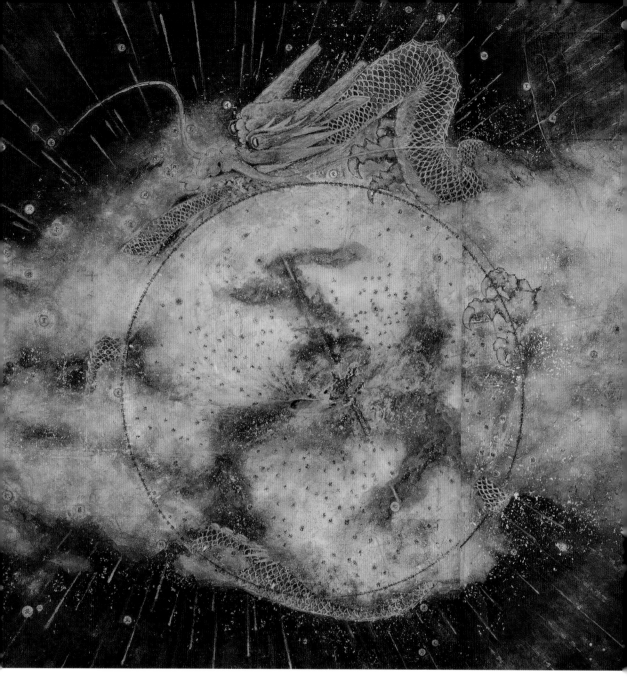

Black hole (*Big Bang:*
E = mc² detail).

A third dragon swirls maternally around a supermassive
black hole that spins at the heart of our galaxy, which is a spiraling
activity of gravitationally bound forms. Tantamount to the weight
of 4 million suns, our black hole is 26,000 light-years from earth.
(For a relative sense of time and distance, we see the sun set eight
minutes after it drops below the horizon.) Our black hole's accretion
disk of superheated gas and dust is about 9 light-years across. Its
event horizon, the point beyond which not even light can escape the
immense gravitational force of the black hole, extends some 8 million

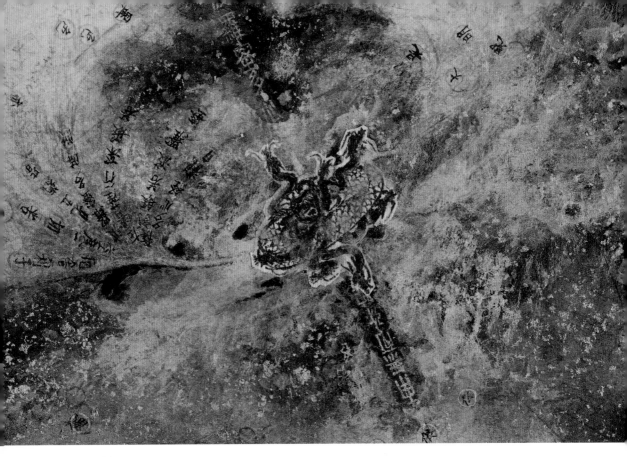

Eight-headed dragon at center of black hole (*Big Bang: E = mc²* detail).

miles. At the point of singularity, black holes are intensely dense with matter, not empty holes at all.

To infuse the black hole with visual vigor, Iwasaki painted an eight-headed dragon to writhe at its center. A potent image from Japanese mythology, the eight-headed dragon is the source of one of the Three Sacred Treasures of Japan, including the Kusanagi sword. Legend maintains the sword came out of the dragon's tail and is now hallowed in the Atsuta Shrine in Nagoya, not far from where Iwasaki lived. Iwasaki also animated the black hole with two full copies of the *Heart Sutra* to auger dense energy.

He interprets a black hole as a purifying agent, for its gravitational force pulls interstellar debris toward itself. As matter approaches the hole, it swirls into the accretion disk where the searing heat transforms the debris into energy. Metaphorically, it dissolves delusions, purifies karma, and incinerates greed and hatred. This matter fuels jets that radiate light deep into the universe. That which falls beyond the event horizon of the black hole extinguishes the flame of suffering. In this way, black holes—fueled by the energy of emptiness—are cauldrons of compassion that generate immense gravitational force to absorb suffering. Black holes are bodhisattvas in astrophysical form that transform suffering into compassion.

A contemplative figure stands on a mountain range in the lower left corner, reflecting how we, too, can function like black holes. Our bodies pulse with the remains of stellar explosions as iron courses through our veins, affirming we are an integral part of this cosmic activity.[51] Powered by the wisdom of emptiness, we, too, are capable of transforming suffering into compassion. We can burn off the causes of suffering and radiate rays of compassionate light.

Although Iwasaki alludes to origins with "Big Bang" in the title, he associates it with Einstein's 1905 theory of special relativity equation: $E = mc^2$. In so doing, he avers origins *are* transformation and interprets $E = mc^2$ as scientific language to articulate the *Heart Sutra*'s teaching: "Form is emptiness; emptiness is form." After completing this painting, Iwasaki reflected, "The karmic tie that binds all beings brings about the cycle of life and death. I, too, am bound by this recurrence of the life cycle. The occurrence of the big bang gave rise to my being. For this I simply bow to the Universe." Through this masterpiece, Iwasaki enraptures viewers to behold the boundlessness of the universe and experience our interrelatedness, thereby healing the delusion of separateness that causes so much loneliness and despair.

Pilgrim on earth (*Big Bang: E = mc² detail*).

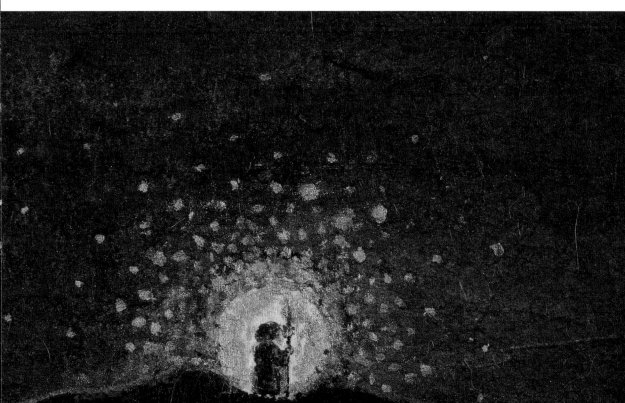

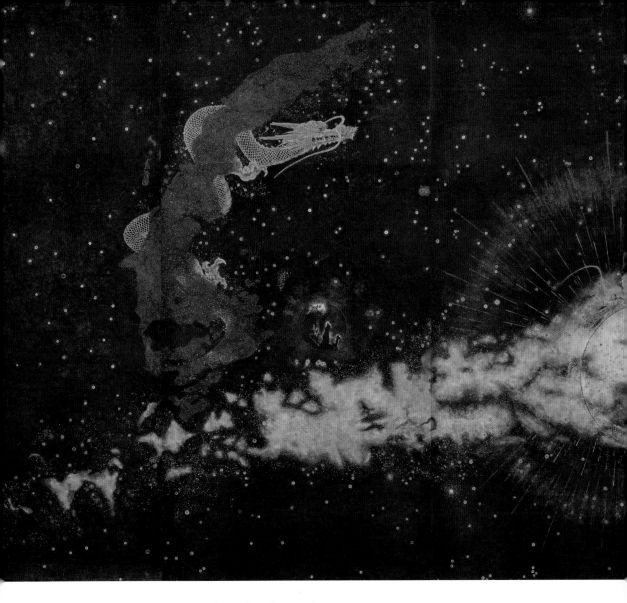

As emptiness is form, form is emptiness,
So, too, energy is mass; mass is energy.
There is birth and death. There is no birth and death.

Delusional, our spinning galaxy is a Wheel of Suffering.
With no fear, ignorance, attachment, or hate,
Our galaxy is a Wheel of Liberation,
Swirling with wisdom and compassion.
Swallowing tail, the dragon whirls.

Gazing, the seeker contemplates,
"Where am I?"
Home.

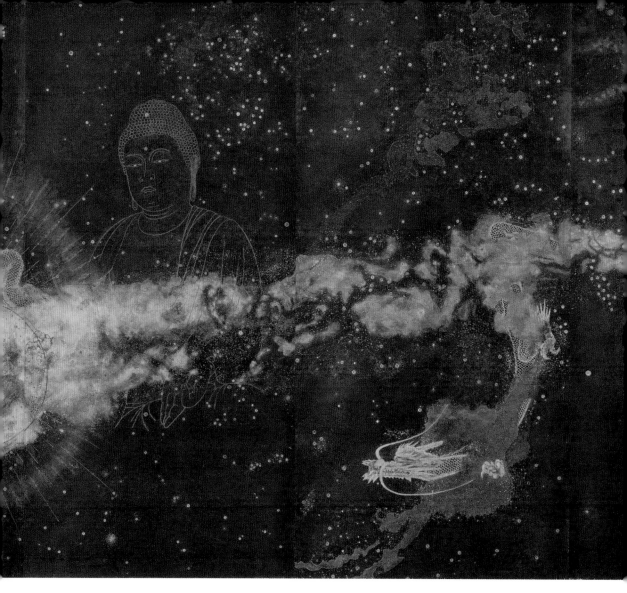

Big Bang: E = mc² detail.

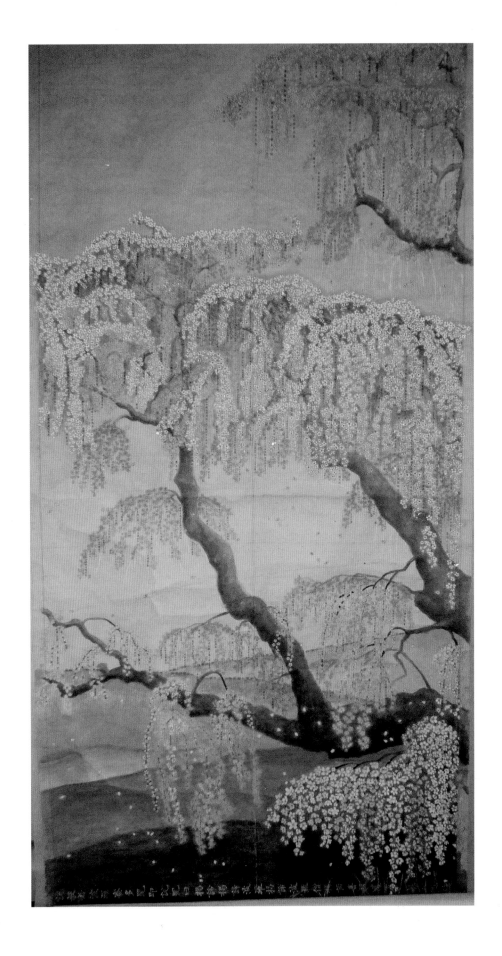

FLOWERING EVANESCENCE
(approx. 175 x 75 cm)

What will be my last thought?

After Iwasaki suddenly passed away during the full-blooming of the
cherry blossoms in 2002, whenever I went to visit, no matter the
season, I saw that his widow kept one of his unfinished paintings
displayed in their formal room. The beauty of the painting bursts forth
in the thousands of soft pink cherry blossom petals he had delicately
animated with the *Heart Sutra*. During the summer of 2014, Mrs.
Iwasaki let me spend significant time alone in the room where he had
painted. Trusting me to breathe life into his work, she permitted me
to look through his books and papers. Among folded-up paintings that
were failed experiments or incomplete, I found plans for a fourteen-
feet-ten-inch-wide, six-scroll painting of a weeping cherry tree, the
twelve-hundred-year-old *Miharu Takizakura* in Fukushima Prefecture.
The panel on display in the formal room was the most complete.
He had started painting two other central panels filled with lacelike
cherry blossom petals, but the *Heart Sutra* had not been added yet.
Proposed for the far-left scroll was the pilgrim he saw as himself and
as any viewer of the painting. The pilgrim has journeyed through

Sketch of *Flowering
Evanescence* (approx.
175 x 75 cm)

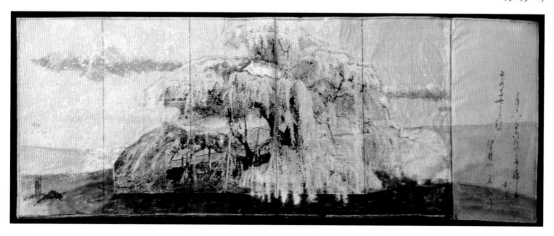

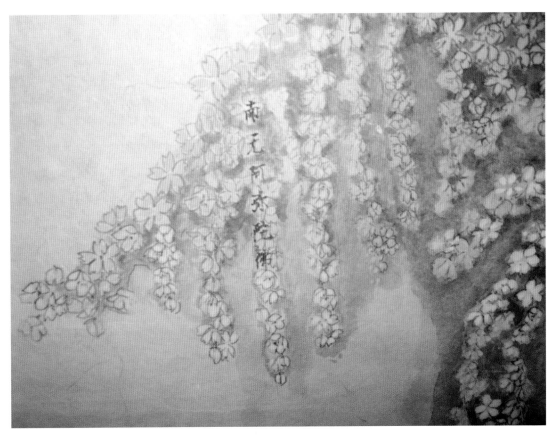

Flowering Evanescence II, detail of "Namu Amida Butsu" in incomplete cherry blossom painting.

many vistas—atop Mount Fuji, the foot of waterfalls, the edge of lightning storms, the outskirts of our galaxy—and finally beholds the quintessential expression of the beauty of evanescence, a cherry tree in full bloom. Proposed for the far-right scroll was the fluid script of a poem by the revered twelfth-century Buddhist poet Saigyō.[52] Taking time to decipher the highly refined calligraphic script, the import of this painting slowly dawned on me.

> ねがわくははなのしたにてはるしなん
> そのきさらぎのもちづきのころ

May I pass away under the flowers of the spring full moon.

He knew. Then I found it. On one of the folded sheets covered with cherry blossoms, still waiting their turn to have the *Heart Sutra* wisdom encoded into their petals, a single line of sinuous red calligraphic script caressed by pink petals. "Namu Amida Butsu. Praise to the one who radiates the wisdom of limitless light."

Iwasaki's doctors had run tests, though in keeping with the Japanese practice, they did not tell him about the cancer ravaging his

body. His widow later found the section of the home medical dictionary underlined where his type of cancer was explained. Still bicycling to get around, he had a few weeks at home before he was hospitalized the last week. She knew he had done some painting during that time. He knew he would not finish this masterpiece of ephemeral beauty. Spring full moon was coming. With palms together and head bowed, he released himself into *Flowering Evanescence* as he scripted his final prayer. Returning to the cosmic womb of the Mother of All Buddhas, Prajñāparamitā, he merged with the healing mantra he had painted thousands of times at the end of the *Heart Sutra*:

> *Gyate, gyate, hara gyate, harasogyate, Bodhi, sowaka.*
> Gone, gone, gone beyond, gone wholly beyond. Awake! Joy!

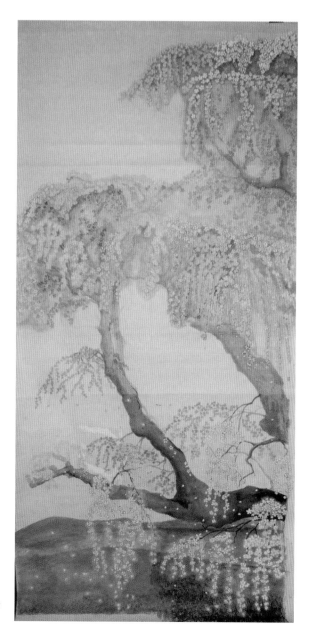

Flowering Evanescence II
(approx. 175 x 75 cm)

HEALING ART, HEALING HEART

A work of art elicits and accentuates this quality of being a whole and of belonging to the larger, all-inclusive whole which is the universe we live in. This whole is then felt as an expansion of ourselves.

—JOHN DEWEY, *Art as Experience*

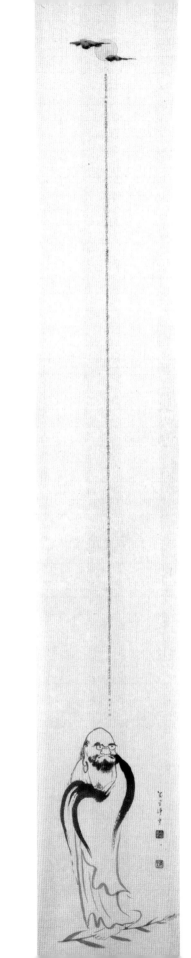

VISUAL SCRIPTURE

The ancient wisdom of the *Heart Sutra* endures through the vicissitudes of each era, helping every new generation combat the tenacity of delusory perception. Delusion consistently promotes isolating and divisive acts and fosters narrow-minded and small-hearted behaviors. These perennial problems are exacerbated by technology, enabling us to generate global suffering at an unprecedented pace. Technological portals accelerate our fragmentation by facilitating new forms of disconnection that foment insecurities and popularize hatred. Yet electronic communication also provides the capacity to connect in almost preternatural ways. We can access events and the thoughts of people around the world through our fingertips. Like never before, we can choose what we feed our minds and hearts. We can propel ourselves deeper into a struggle for survival or impel ourselves to cultivate skills for wisely navigating this deluge of choices.

Iwasaki's art stretches across cultural, linguistic, and philosophical divides to forge a path forward. His paintings are a salve for the toxic flares coursing through cyberspace, threatening to sear our heart-minds with incendiary poison. Inviting us to experience our interrelatedness, they open up a view to harmonious connections. He directs our gaze beyond environmental destruction, hate-fueled injustices, and acts of terror. Placing viewers in a vast cosmic context, he emboldens us to be like the solar Fudō in *Eclipse*, who discerns what limits our view of reality and uses the lasso of emptiness to remove obstructions. Like his skeletons ascending secure lines of wisdom in *Climbing Out of Hell*, we, too, can climb out of self-inflicted hells. Instilling courage to dissolve our fears into thin air, we can offer ourselves like *Healing Incense* that enkindles in order to emit its fragrance. *Raining* compassion on our hearts, Iwasaki offers cleansing healing to help us see with perceptive acuity.

OPPOSITE:
Daruma (100 x 20 cm)

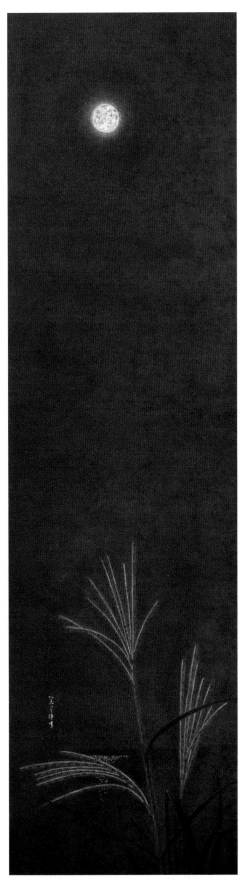

Iwasaki's art is visual scripture. His images materialize words and infuse them with metaphysical meaning as they reach people in daily life. People need not read the classical language of the text to understand and benefit from its transformative power. That the images are composed of words of scripture, however, is vital to their impact. Embedding the meaning of the *Heart Sutra* in his paintings, he shows us what reality looks like when viewed through the lens of wisdom and seen with eyes of compassion. What comes into focus is that we are an integral facet of a vast and interconnected cosmos. Seeing in this way, we can experience ourselves as connected, important, and vital. His visual scripture beckons us to see beyond the surface and contemplate the depths.

Iwasaki is aware that senses are tools of interrelating. Textures, sounds, flavors, aromas, images, and thoughts are conduits for connecting. Challenged by how to paint an object in a way that fosters connection, he experimented with perception. He paints familiar images to capture people's attention, yet defamiliarizes them by strategically adding space to show things in a new light. He leaves open enough space to allow a fresh consciousness to shine through and expand the viewer's perspective. Not wanting to misdirect our attention and leave us thinking we are discrete entities, Iwasaki does not isolate a form from its context with solid lines that divide and separate. By using permeable characters, he does not commit "the Fallacy of Misplaced Concreteness" and take events out of sync with the impermanent flow of reality.[53] The form dissolves when engaging with objects in this way, thereby dramatizing the

Moon and Pampas Grass (100 x 29 cm)

Buddhist teaching that form is emptiness. The perspective of the images—whether of microscopic particles, objects that are visible to the naked eye, or cosmic phenomena that are light-years away—is all focused at a very precise magnitude: close enough to see that they are empty of own-being, yet far enough away to see the forms in their wholeness— that is, interdependently arising with the whole universe. The tiny characters lure viewers to lean in for closer examination and engage with the space. They quietly whisper, "Our perception of reality is constructed."

It is the reification, not the form itself, that is delusional. Reification of form is a delusion that baits fear, attachments, and anger. We sow seeds of suffering whenever we fail to account for underlying connections. I found this concern captured in a brief but poignant comment Iwasaki made when we were walking together past a field near his home. Lamenting that "fireflies don't come here anymore," he was stirred by the implications of this loss. Like canaries, fireflies are an indicator species. Their absence is a harbinger that something is awry in the environment. His paintings are a plea to wake up to the interconnected nature of reality and healing.

In addition to understanding the fullness of Iwasaki's intent, viewing his art in historical and cross-cultural contexts illuminates its significance. His paintings join the vibrant tradition of visual images found on church and stupa structures to both teach and create sacred space. Where the paintings are innovative is in the use of sacred text to create the images. Tracing how a ninth-century Zen

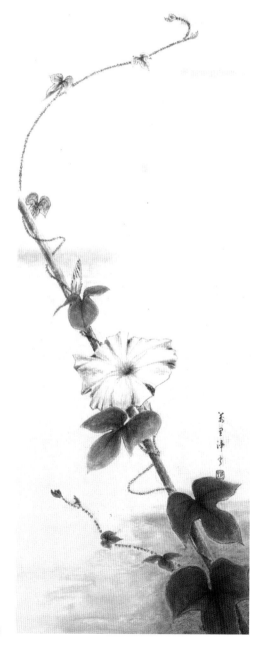

Morning Glory (86 x 25 cm)

master's perception changed during his journey to enlightenment offers a helpful interpretive lens.

Before embarking on the path to enlightenment:
mountains are mountains.
In the midst of learning about emptiness and ultimate reality:
mountains are not mountains.
Experiencing enlightenment: mountains are mountains.

Though my intention is not to rank art in order of enlightened awareness, this aphorism can help us see distinctions in the way artists focus on perception. Offering an illustrious range of realistic imagery—portraiture, still life, landscape—premodern Western art captures moments of reality as we know it. Such representational art corresponds to the first "mountains are mountains." Form *is* form. Abstract art illustrates the principle of "mountains are not mountains." This is a more critical understanding of reality. Form is deconstructed and evokes how "form is emptiness." It shows us reality as reimagined in response to scientific revelations that challenge common notions of reality. From discovering that atoms are not solid to detecting billions of galaxies in a rapidly expanding spacetime continuum, the familiar everyday world seems less real and less significant.

Seamlessly merging techniques honed over the centuries to create traditional forms of Buddhist iconography, Iwasaki's paintings are weighted with the gravity of the past yet buoyed by themes that reflect contemporary concerns. Esteeming scientific forms such as DNA, atoms, nebulae, and black holes, Iwasaki weaves together the old and new with the realistic and idealistic. Having been raised in a Buddhist culture, he was not surprised by scientific findings that revealed there are no solid particles. This discovery simply confirmed the long-standing Buddhist teachings on transformation, impermanence, emptiness, and interbeing.

By infusing his paintings with the *Heart Sutra* teaching "form is emptiness; emptiness is form," Iwasaki's images of precisely represented phenomena—pampas grass, lightning, skeletons, and spiral galaxies—integrate scientific knowledge with Buddhist wisdom. Having fathomed that emptiness *is* form, Iwasaki reveals the enlightened view of "mountains are mountains." Rather than leaving us estranged and dislocated, his paintings present a view of reality that is recognizable, yet different. In the law of conservation of

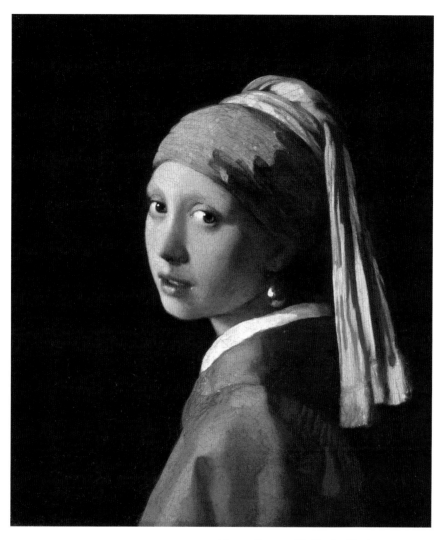

Johannes Vermeer, *Girl with a Pearl Earring* (44.5 x 39 cm)

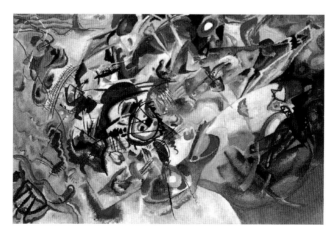

Vasily Kandinsky, *Composition VII* (200 x 300 cm)

energy, Iwasaki saw a key to unlock our compassionate nature. Forms change, but vital energy is never lost. We are all changing patterns of the same energy. We are inextricably interrelated. Iwasaki's intricate renderings of familiar forms interlaced with the *Heart Sutra* illuminate our impermanent and cosmic context by revealing that the changing nature of forms is due to our interrelatedness. In the face of personal angst, social distrust, and global uncertainty, his paintings offer a vision of our wholeness and the necessity of compassion. He lures us by showing us the beauty of everyday forms.

The subtle dimensions of Iwasaki's tiny-character art cultivate a

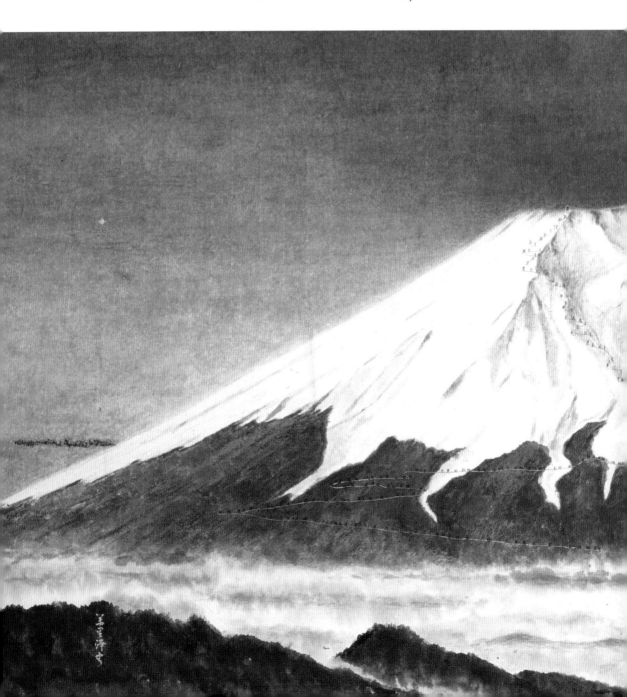

relationship between viewer and artist. When the viewer steps back and sees the form, they complete the image. In this way, Iwasaki continues to nurture connections, extending his engagement with the vastness of our cosmos. Resounding with the kinship he felt with microscopic images, insects, hallowed icons, and galactic worlds, his art draws the viewer into his circle of intimacy.

Painting was a contemplative practice for Iwasaki, requiring samadhi-like concentration to paint each brushstroke as a manifestation of experiencing ultimate reality. He calculated carefully and executed each stroke with meticulous precision. Each stroke is a single moment, a

Snow-Peaked Mt. Fuji
(120 x 61 cm)

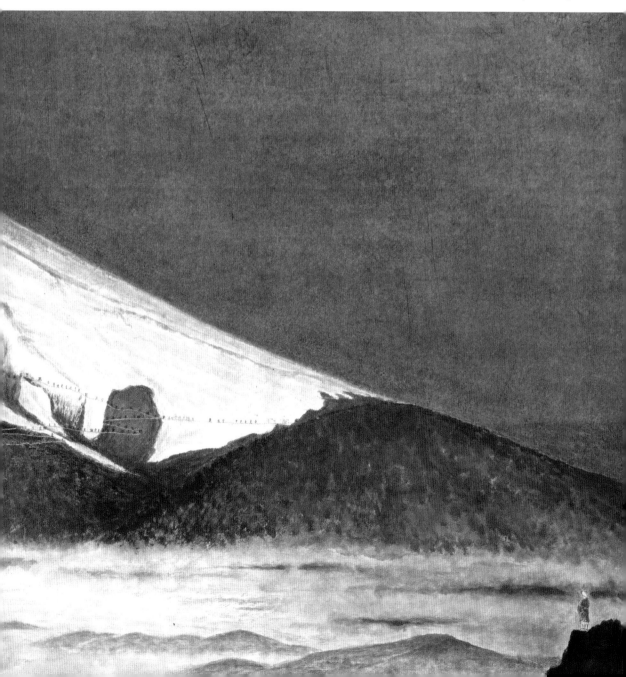

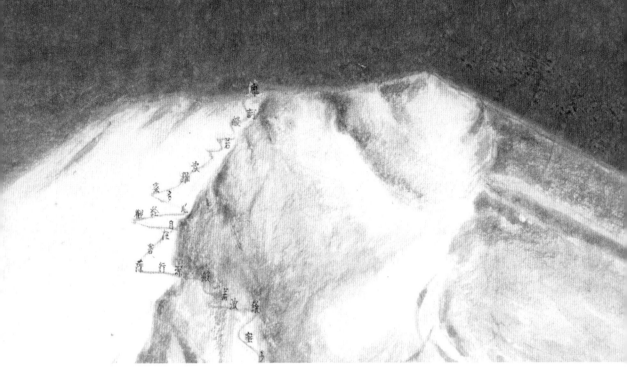

Snow-Peaked Mt. Fuji, detail
of Heart-Sutra-hikers.

universe made manifest, a fleeting moment hovering in eternity. Each of
Iwasaki's brushstrokes is a prayer to alleviate the suffering of all beings.

LIBERATING WISDOM

Telescopes and microscopes enable us to perceive distant and
miniscule phenomena on a scale we can sense. They extend our ability
to see into the depths of the present moment and to see what is here
in expanded detail. Art can do that too. By shaping each form with
the same characters of the *Heart Sutra*, Iwasaki illustrates the key to
wisdom's harmonizing capacity: the same energy propels all forms—
waterfalls, ants, DNA, an eye, a red giant, a hydrogen atom—fluidly
changing patterns in a dazzling array of combinations. Pulsing with
the aesthetic rhythm of Chinese characters, Iwasaki's paintings offer
an amplified awareness of here and now.

The nature of form is to form, unform, reform, and transform,
as movingly evinced in *Transmigration*. Illuminating that form *is*
transforming activity, Iwasaki's art is an invitation to experience
ourselves as impermanent and to sense the empty quality of forms.
When we are aware of ourselves as interdependent phenomena—
including the phenomena of thoughts, sensations, and feelings—fear,
hatred, and greed do not arise.

Iwasaki shows us how seeing ourselves as interdependent with
the universe involves severing delusions, restoring balance, removing

obstacles, and distinguishing the roots of suffering from the sources of compassion. His *Sword of Wisdom* encourages us to wield our minds like finely crafted swords and sever false assumptions. Untethered, we can see we had been so tightly gripping the bars of a cage that we could not see we had always been on the outside, ever free to fly. He exhorts us to be like *Lightning*. We, too, can only act in the present moment. We can only be effective in restoring balance when engaging the dynamics of current conditions. We, too, can burst with electrifying energy to wake up. As in *Cat's Eye: Buddha's Mirror*, once the distorting cataracts of desire and aversion are removed, our eyes of wisdom can see there is no "me" or "you." We can see we are the source of compassion pulsing through the universe. As in *Blossoming Buddha*, we, too, are like the lotus blossoming in the mud. We, too, receive necessary nutrients from conditions that appear adverse yet are a felicitous stew that supports our flourishing. Seeing through the *Heart Sutra* lens reveals how to dissolve divisions and militate against delusion born out of falsely reifying objects. In focusing on the fullness of the present moment, here and now, his paintings are unguents that help heal the fractures and punctures to our interrelated whole.

Iwasaki trains us to see connections, interrelatedness, and change, and to enjoy how forms transform. His visual ministrations unblock the mental dams that hold us back, enabling us to freely flow in the current of myriad causes and conditions. When one sees reality this way, we recognize that we are already a fluid part of the stream and already engaged in intensely harmonious activity. This is the nature of our cosmic interbeing. With delicate, nonthreatening brushstrokes, his *Heart Sutra* art illustrates interbeing. His painting *Atom* urges us to feel an intimate connection to a hydrogen atom, endearing us to subatomic particles. In *Grain of Rice*, a mother's hand tenderly holding a grain of rice for meditative consumption helps us realize we are nourished by the vast causes and conditions of the universe. This is the crux of wisdom into the nature of boundlessness. When you sense interbeing, you experience yourself as integral to the universe, as does the contemplative figure in *Big Bang: E = mc²*. When we experience boundlessness, we experience the emptiness of the whole.

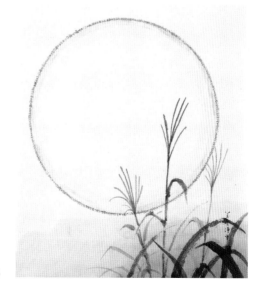

Ensō Moon (13 x 12 cm)

From the perspective of emptiness, impermanence, connections, and beauty come into focus, and the illusions of divisiveness, permanence, and despair fade away. Experiencing boundlessness opens up a harmonious tableau. Beauty welcomes all as it draws us out of isolation, nourishing the greater whole. Beauty allures us to melt the delusion of separateness, even the delusion that death severs connections. As averred in *Adashino: Graveyard of Stone Buddhas*, death is not an end. It is transformation. Death is integral to interbeing. The cacophonic dissonance emanating from death can feel arrhythmic, however, and leave us feeling left out of the harmony of the cosmos. Yet we are continuously embraced in sonorous waves ever swelling and cresting throughout the universe. Eddy currents are nursed gently into the movement of the waves. As in *Radiating Pearl*, the thump of the wooden drum emanates sound waves that synchronize chanters to a steady beat. When we are finely attuned, we can harmonize our heartbeats to the heartbeat of the cosmos, a mellifluous symphony of beauty in motion.

Unfurling a long arc to shape civilization, Iwasaki's lucid art lures us to see broadly and deeply. Making ideas and feelings visible, his art expresses a bounty of thoughts and emotions.[54] He ushers us to illuminating vistas that intimate creative responses to prevailing problems. His images inspire us to be in touch with exquisite emotions that often elude the logic that words and grammar capture. Through the immediacy of sensorial experience, his art engages concepts in a way that can be felt more keenly than cognized. Intuiting invisible forces that animate life—from microscopic to telescopic phenomena—Iwasaki's art moves the heart and mind in subtle, profound, and evocative

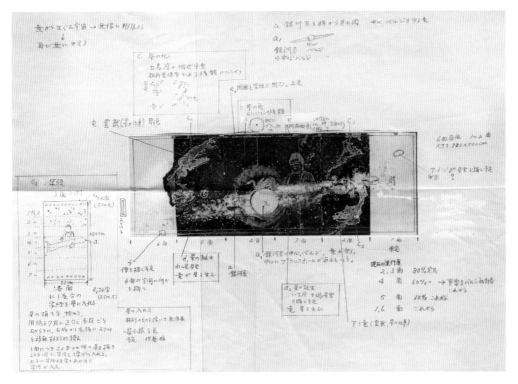

Iwasaki's plan for *Big Bang* mailed to author as continuation of conversation started in Nagoya tea shop. It took him two years to complete this painting.

Koi Ascending
Waterfall
detail.

ways. Stimulating awareness of vast and intricate connections through concrete particulars, his paintings present perceptions of the world that can transform the way we perceive ourselves. As the *Mandala of Evolution* shows us, all forms are family. As the *Big Bang: E = mc²* illustrates, everywhere is home. This is healing. Iwasaki invites us, too, to experience compassion as a force in the universe, in evolution, in each *Atom*, each strand of *DNA*, in all *Bubbles* and in each *Dewdrop*. By showing us we are integral to vast cosmic activity—from quarks inside a nucleon, to dewdrops rolling off a lotus leaf into a pond, to ants crawling on the earth, to moonlight shining on the ocean, to black holes churning inside galaxies—his art beckons us to shift our perception from suffering quagmires to liberating wisdom.

BODHISATTVA FOR OUR TIME

Like the pilgrim meeting the Healing Buddha in *Pilgrimage to a Pagoda*, we, too, have arrived. We are home. Having journeyed through Iwasaki's *Heart Sutras*, we have attuned to the activity of solar prominences, planetary motion, waterfalls, star nurseries, blossoming flowers, and the stirrings of healing hearts. We have intimately experienced the interdependent flow of the universe and witnessed its evanescent beauty. The vision of boundlessness entices us to move in harmony. Connecting and flowing, we feel the pulse of the cosmos and hear the peal of compassion.

Compassion inspires creative and harmonizing activity, eight facets of which I highlight in my organization of Iwasaki's oeuvre. Interbeing is the lodestar for discerning compassionate action, which pivots on the fulcrum of suffering and not suffering. Compassionate action does not hinge on the concepts of right and wrong. These are reifying categories that remove an act from the continuous flow of interdependent activity. Judgments miss their mark because they stop and point, whereas compassionate actions flow with the dynamic activity of boundlessness. Alleviating suffering requires being in tune with changing conditions. Since all actions have ramifications and no activity occurs in isolation, we cannot act without generating ripples across the cosmic pond. When driven by delusion, desire, or hatred, an action generates suffering and obfuscates connections. An action motivated by compassion emerging from the nondual wisdom

Falling Japanese Maple (100 x 17 cm)

of boundlessness sets into motion waves that support healing. As a tiny *Dewdrop* has an impact, each of our actions do too, though much undulates beyond conscious view.

Expanding our purview and not resisting the flow of boundlessness facilitates acts of compassion. It requires resilient strength, like *Bamboo*, which does not resist when weight bears down on its branches. It lithely bows, rather than breaks. Nurturing, too, involves supple awareness. It requires being fully engaged in the present moment and listening with one's whole body, attuned to the whimpers and wails, the triumphs and travails. As in *Mother of Compassion*, we have each been embraced in a nurturing womb. We, too, can nurture with parental compassion. To raise a *Baby Buddha* requires wisdom, the peerless catalyst for melting the divisions and delusions that threaten to shutter our hearts. Keeping our hearts open sometimes requires forgiving. Like a *Ringing Bell* that attunes us to compassion, we can modulate the movement of our hearts to generate sympathetic resonance that opens us to richer harmonies. As an offering of creative concern for peace, try seeing a perceived enemy composed with *Heart Sutra* characters. Such practices, like *Candle Light*, illuminate. Iwasaki saw each painting as a flame emanating with the wisdom that "all things are Buddha."[55] Awakening our hearts to

Galaxy
(82 x 73 cm)

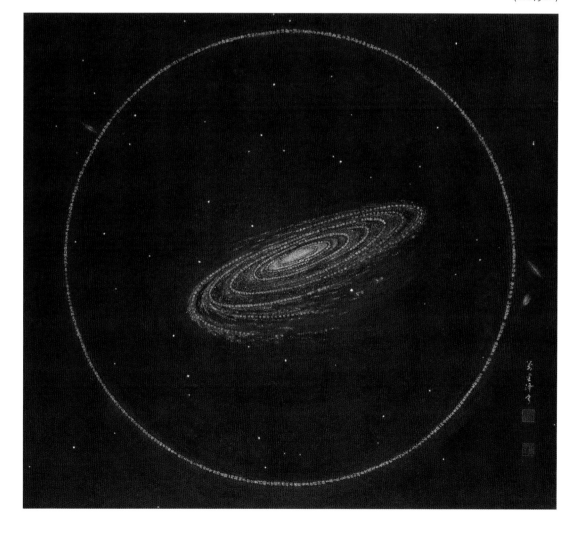

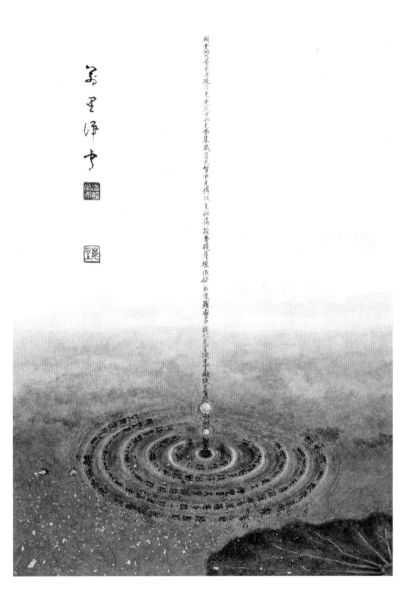

Dewdrop: Buddha's Tear, detail.

compassion, we are free to play in the beauty of the present moment. We can feel unalloyed delight and, like *Sparklers*, ignite incandescent embers of joyful flourishing. As in *Swirling Emptiness*, all is harmoniously embodied. In Alfred North Whitehead's words, "Suffering attains its end in a Harmony of Harmonies."[56] Being in harmony is healing.

Iwasaki's artwork is a beacon for the twenty-first century.[57] His life and art exemplify how to live a *Heart Sutra* life. A wise visionary who lived through the ravages of war, Iwasaki felt hunger in his belly and fear racing through his nervous system. He understood the horrors of atomic warfare. His vision of wholeness is not made of naïve dreams. It is founded in experiencing the depth of human depravity yet still attaining the height of embracing love and tender kindness. Transposing textual

scripture into living wisdom, Iwasaki celebrates common objects and
events of daily life as a sphere of sacred beauty, ethical purpose, and
ultimate meaning. Expressing the interdependent, impermanent, and
empty nature of phenomena, he delivers profound insights through his
evocative images. By merging the spirit of the investigative traditions of
science and Buddhism, the paintings reveal how the art of perception
can generate healing insights. With the compassionate aim of relieving
suffering, these paintings offer visual wisdom for a multicultural,
scientifically informed, image-driven world. His imagery points to the
complementarity of scientific and Buddhist paradigms as they converge
in a message of mutual responsibility and collaborative experiments to
unlock the code to compassion.

Interdependent from the subatomic level to the intergalactic, the
ethical import of the paintings directs attention beyond egocentric,
ethnocentric, and species-centric moralities of right and wrong
to an ethic based on interrelatedness and shared destiny. Visually
articulating what I call an "aesthetic ethics of interbeing," Iwasaki
gestures toward the far-reaching reverberations of our choices
and actions in order to inspire empathic concern and motivate
compassionate intervention. His vision of wholeness is healing to our
greed-driven economy, strident politics, aching environment, and
war-torn hearts and bodies. Harmonizing scientific with spiritual,

Mayfly detail.

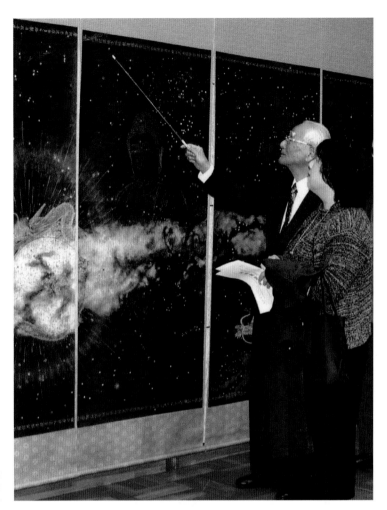

Iwasaki explaining a detail of *Big Bang* at an exhibition in Handa, Japan.

physical with invisible, measurable with nonmeasurable, everyday with ultimate, Iwasaki's paintings embolden us to see ourselves as porous, dynamic, and interdependent—to see the wisdom of compassion.

Iwasaki prayed as he painted, aspiring that "the merit of this work will help bring an end to the suffering of all sentient beings." As a composer of visual scripture, his brush dances in rhythm with the harmony of harmonies. As a transmitter of wisdom, his heart beats with the heartbeat of the cosmos. As a teacher of the path to freedom from suffering, he bequeaths a healing treasury upon our age. Wielding burnished brush and lustrous gold, Iwasaki is a bodhisattva for the modern world. Painting enlightenment, he opens the heart of compassion and bids us to view the cosmos through eyes of wisdom and behold the circle of healing in our midst.

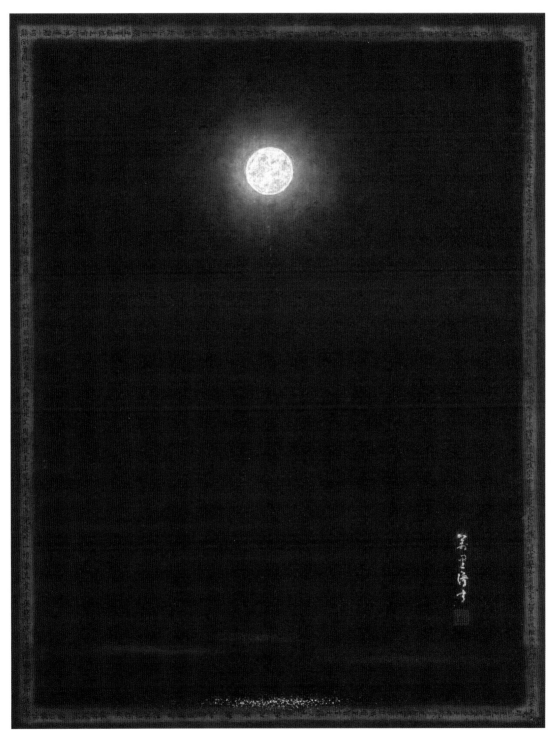

Moonlight (41 x 32 cm)

NOTES

1. Kazuaki Tanahashi and Joan Halifax, *The Heart Sutra: A Comprehensive Guide to the Classic of Mahayana Buddhism* (Boulder, CO: Shambhala Publications, 2014), 3–4.

2. "Nagai" is a pseudonym for the woman who called me on March 6, 1999, to go see the exhibit "Viewing the *Heart Sutra*," Nagoya City Museum, March 2–7, 1999. Iwasaki also exhibited his art in 1993 and 1996 at Handa Hakubutsukan (Handa Museum). After completing the *Big Bang: E = mc²*, he held exhibitions at Handa Fukushi Bunka Kaikan (Handa Cultural Welfare Center), January 20–25, 2001, and the Meguro Ward Museum of Art in Tokyo, June 13–17, 2001.

3. Japanese convention places surname first. Iwasaki is his surname. Tsuneo is his given name.

4. Iwasaki Tsuneo, *Hannyashingyō o miru: Saimitsuji shakyōga nyūmon* 般若心経を観る：細密宇写経画入門 (Tokyo: Nichibō Press, 1999), 26.

5. Donald Lopez Jr. furthers the earlier Indian origins of the *Heart Sutra* in *Elaborations on Emptiness: Uses of the Heart Sutra* (Princeton, NJ: Princeton University Press, 1996), 241. Jan Nattier compiles evidence leading to a later Chinese origin in "The Heart Sūtra: A Chinese Apocryphal Text?" *Journal of the International Association of Buddhist Studies* 15, no. 2 (1992): 153–223.

6. Lopez, *Elaborations on Emptiness*, 5.

7. It is now University of Tsukuba.

8. During his tenure, the schools joined and became Handa Kōtō Gakko.

9. Iwasaki studied the *Heart Sutra* primarily with Matsubara Taidō, a major Zen teacher who authored over 130 books.

10. Iwasaki's oeuvre includes over three hundred paintings, located in various places, known and unknown. He gave numerous works away, and he did some images more than once. His family and friends have many works, as well as Handa Cultural Welfare Center (*Galaxy, Radiating Pearl*), Rev. Matsubara Taidō's temple, Ryūgen-ji, in Tokyo (*Moon Viewing*), and Paula Arai (*Lightning, DNA, Daruma, Sparkler, Moonbeam, Baby Buddha*). He did some near duplicates of his paintings, including *Mandala of Evolution* without the Ouroboros, *Radiating Pearl* (one in gold, and one in gold and silver), several versions of *Baby Buddha* and *Raining*, and one hundred of *Moonbeam*, which he painted to express gratitude to the people who supported him.

11. For an English translation, see Keiyo Arai, trans., "The Sutra on the Profundity of Filial Love," in *Apocryphal Scriptures*, BDK English Tripiṭaka Series (Berkeley: Numata Center for Buddhist Translation and Research, 2005), 121–26.

12. Arai, "Translator's Introduction," in *Apocryphal Scriptures*, 119.

13. The *Dhammapada* is a foundational Buddhist scripture that articulates in verse teachings on recognizing ways of being that generate suffering and offers guidance on living a life of liberation and peace.

14. My translation, with some lines from *The Dhammapada*, trans. Ananda Maitreya (Berkeley: Parallax Press, 1995), 5.

15. Kūkai would enjoy Iwasaki's paintings, for Kūkai too dissolved the boundaries between letters and images to reveal the realm of enlightenment. For further discussion, see Pamela Winfield, *Icons and Iconoclasm in Japanese Buddhism: Kūkai and Dōgen on the Art of Enlightenment* (New York: Oxford University Press, 2013), 71.

16. It is now part of Papua New Guinea.

17. Hiromi Tanaka, "Japanese Forces in Post-Surrender Rabaul," in *From a Hostile Shore: Australia and Japan at War in New Guinea*, ed. Steve Bullard and Tamura Keiko (Canberra: Australian War Memorial, 2004), 148. http://ajrp.awm.gov.au/ajrp/ajrp2.nsf/WebI/Chapters/$file/Chapter7 .pdf?OpenElement

18. Tanaka, "Japanese Forces," 146.

19. Tanaka, "Japanese Forces," 150.

20. Thich Nhat Hanh, *The Other Shore: A New Translation of the Heart Sutra with Commentaries* (Berkeley: Parallax Press, 2017), 30.

21. Robert Thurman's "double exposure" metaphor was formulated in a graduate seminar, "Emptiness and Compassion" (Harvard University, Cambridge, MA, January–June, 1986).

22. Tenzin Gyatso, *Essence of the Heart Sutra: The Dalai Lama's Heart of Wisdom Teachings* (Somerville, MA: Wisdom Publications. 2005), 129.

23. Japanese Buddhist amulets are commonly empowered by the words written inside them.

24. The other nine practices are: making offerings, giving to others, listening to others' recitation, reading sutras, upholding the teachings, explaining the teachings to others, and reciting, pondering, and putting into practice the teachings. K'uei-chi, *A Comprehensive Commentary on the Heart Sutra*, trans. Shih Heng-ching and Dan Lusthaus (Moraga, CA: BDK America, 2001), 123.

25. Ryuichi Abe, *The Weaving of Mantra: Kūkai and the Construction of Esoteric Buddhist Discourse* (New York: Columbia University, 1999), 155.

26. George Sansom, *Japan: A Short Cultural History* (Stanford, CA: Stanford University Press, 1978), 141.

27. Tomoko Otake, "Sutra-Writing by Hand to Boost the Brain," in *Japan Times*, December 24, 2006. She cites research of Tohoku University professor Ryuta Kawashima, who measured the cerebral activity of one thousand seniors and found more activity when they did sutra copying than 160 other types of activities.

28. Manabe Shunshō, "Shabutsu" in *Anatadake no Hannyashingyō*
「写仏」in『あなただけの般若心経』(Tokyo: Shogakukan, 1990), 129.

29. Iwasaki, *Hannyashingyō o miru*, 29.

30. For further details on the tiny-character tradition in Japanese Buddhist art, see Halle O'Neal, *Word Embodied: The Jeweled Pagoda Mandalas in Japanese Buddhist Art* (Cambridge, MA: Harvard University Press, 2018).

31. According to East Asian concepts of the body, *hara* refers to the abdomen, the source of power at the core of the body.

32. Analysis of contemporary Buddhist artists indicates "common ground between the creative mind, the perceiving mind, and the meditative mind." Jacquelynn Bass, *Buddha Mind in Contemporary Art* (Berkeley: University of California Press, 2004), 9.

33. "Two Together" references the Shikoku pilgrimage route, where pilgrims often sense they are walking with Kūkai, the eighth-century Buddhist master who traveled this route.

34. Susanne Langer explores how art functions in society in *Problems of Art: Ten Philosophical Lectures* (New York: Scribner, 1957), 131. Masaharu Anesaki expounds on the concepts embedded in Japanese Buddhist art in *Buddhist Art in Its Relation to Buddhist Ideals, with Special Reference to Buddhism in Japan: Four Lectures Given at the Museum* (Boston: Houghton Mifflin, 1915), 30. David Morgan explains the transformative power of art in *The Sacred Gaze: Religious Visual Culture in Theory and Practice* (Berkeley: University of California Press, 2005), 33.

35. Iwasaki, *Hannyashingyō o miru*, 33.

36. Felice C. Frankel and George M. Whitesides, *No Small Matter: Science on the Nanoscale* (Cambridge: Belknap Press, 2009), 42, 66.

37. Fa-tsang's quote is cited in Red Pine, *The Heart Sutra: The Womb of Buddhas* (Berkeley: Counterpoint, 2004), 27.

38. Iwasaki, *Hannyashingyō o miru*, 35.

39. The waterfall is *Nachi no Taki*, in Wakayama Prefecture. It is three hundred meters long.

40. Red Pine, *The Heart Sutra*, 16.

41. Although popularly dated to 609 C.E., F. Max Müller's study makes a strong case for dating it to the eighth century C.E. See his "The Ancient Palm Leaves Containing the Prajñāpāramitā-Hṛidaya Sūtra and Uṣṇīṣa-vijaya-Dhāraṇī" (2–59) and Georg Bühler's remarks in "Palaeographical Remarks on the Horiuzi Palm-Leaf Manuscripts" (63–95) in *Buddhist Texts from Japan*, vol. 1, pt. 3 (London: Oxford University Press, 1881), 64.

42. See O'Neal's *Word Embodied* for more examples and discussion of pagodas painted with the tiny Chinese characters of Buddhist scripture.

43. In this painting, the moon symbolizes obscurations to enlightenment, whereas the full moon is a common symbol for enlightenment in Japanese culture. Juxtaposing *Eclipse* with *Moonbeam* intensifies the warning about mistaken assumptions of enlightenment as it accentuates the teaching that nirvana is samsara and samsara is nirvana.

44. *Ensō* means circle, symbolizing enlightenment.

45. Iwasaki, *Hannyashingyō o miru*, 67.

46. Iwasaki, *Hannyashingyō o miru*, 63.

47. Matsubara Taidō, *Hannyashingyō Nyūmon—276 Moji ga kataru Jinsei no Chie* 般若心経入門—276文字が語る人生の知恵 (Tokyo: Shodensha, 1993) 61–62.

48. Cited in Red Pine, *The Heart Sutra*, 39–40. See *Supplements to the Tripitaka*, vol. 41, 411–24.

49. Iwasaki, *Hannyashingyō o miru*, 33.

50. Iwasaki, *Hannyashingyō o miru*, 95.

51. Jill Tarter, astronomer, Bernard M. Oliver Chair for SETI Research, at the SETI Institute in Mountain View, California. "Are We Alone in the Universe?" *TED Radio Hour*, February 15, 2013, https://www.npr.org/2013/08/02/172140077/are-we-alone-in-the-universe.

52. Saigyō's poem captures his vision to pass away as Sakyamuni did, under the spring full moon. Saigyō did indeed pass away at that time. Predicting the time of one's death is a recognized sign of enlightenment.

53. Alfred North Whitehead, *Science and the Modern World* (Cambridge: Cambridge University Press), 64.

54. Susanne Langer and Margaret Miles develop this idea in their respective books. See Susanne Langer, *Philosophical Sketches* (Baltimore: Johns Hopkins University Press, 1962) and Margaret Miles, *Image as Insight: Visual Understanding in Western Christianity and Secular Culture* (Boston: Beacon Press, 1985).

55. Iwasaki, *Hannyashingyō o miru*, 13.

56. Alfred North Whitehead, *Adventures of Ideas* (New York: Free Press, 1967), 296.

57. Citing Takahashi Chiun (高橋智運), Shingon priest and head priest of Kōtoku-ji (高徳寺). Iwasaki, *Hannyashingyō o miru*, 11.

ABOUT THE AUTHOR

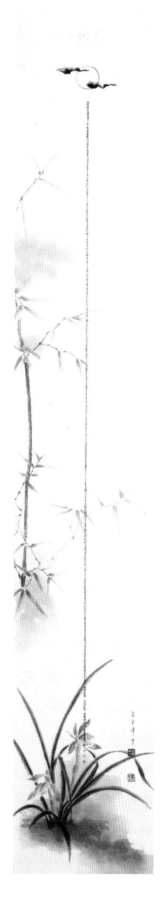

Paula Arai (Ph.D., Harvard University) is the author of
Women Living Zen: Japanese Buddhist Nuns (Oxford University
Press) and *Bringing Zen Home: The Healing Heart of Japanese
Buddhist Women's Rituals* (University of Hawai'i Press), and
co-editor of the *Oxford Handbook of Buddhist Practice* (Oxford
University Press). She did Zen training at Aichi Senmon Nisōdō
nunnery in Nagoya, Japan. Her research has been supported
by the Fulbright Foundation, American Council of Learned
Societies, Mellon Foundation, Reischauer Institute of Harvard
University, American Academy of Religion, and ATLAS (Awards
to Louisiana Artists and Scholars). She is an active public
speaker, leads healing ritual workshops, and has curated a
number of exhibitions of Iwasaki Tsuneo's art. A devoted and
award-winning teacher, Arai was Yuki Visiting Professor at
the Institute of Buddhist Studies and is an associate professor
of Buddhist Studies at Louisiana State University, holding the
Urmila Gopal Singhal Professorship in Religions of India. She
enjoys hiking, playing the violin, and marveling at her son's life
journey.

Imagine yourself as a pilgrim on a path.

Let the paintings guide you on a contemplative journey.

PAINTING ENLIGHTENMENT
EXPERIENCING WISDOM AND COMPASSION THROUGH ART AND SCIENCE

IWASAKI TSUNEO

"Painting Enlightenment:
Experiencing Wisdom and
Compassion through Art
and Science," LSU Museum
of Art, September 2016.

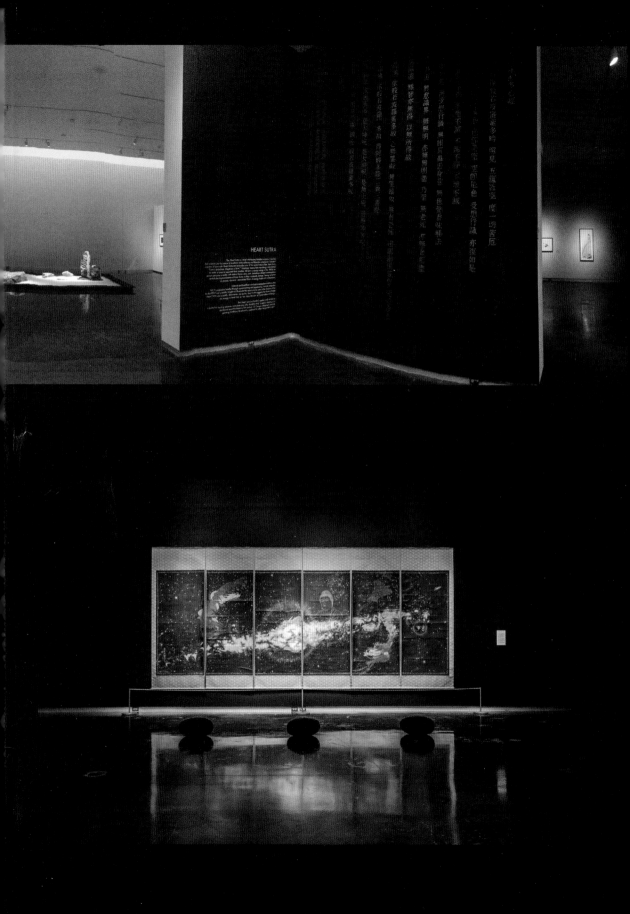

不增不減是故空中无色无受想行識无眼耳鼻舌身

倒夢想究竟涅槃三世諸佛依般若波羅蜜多故得阿

般若心經

芳里淨土